"Paper Talk"

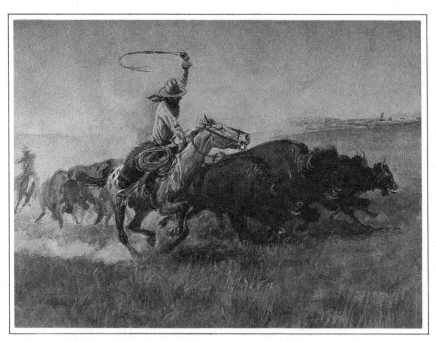

Buffalo Roundup, *watercolor, 1909*

"Paper Talk" Charlie Russell's American West

Edited by Brian W. Dippie

A Ridge Press Book

Alfred A. Knopf Inc., New York, 1979
in association with the Amon Carter Museum of Western Art

Copyright © 1979 by The Amon Carter Museum of Western Art, Fort Worth, Texas. All rights reserved. No part of this work may be reproduced or transmitted in any form or by any means, electronic or mechanical, including photocopying, recording, or any information storage and retrieval system, without permission in writing from the publisher.

Published by Alfred A. Knopf, Inc., 201 East 50th Street, New York, New York 10022.

Published simultaneously in Canada by Random House of Canada, Ltd., Toronto

Prepared and produced by The Ridge Press, Inc.

Printed in the United States of America

Library of Congress Cataloging in Publication Data

Russell, Charles Marion, 1864–1926.
 Paper talk.
 "A Ridge Press book."
 1. Russell, Charles Marion, 1864–1926.
2. The West in art. I. Dippie, Brian W.
II. Title.
ND237.R75A4 1979 709'.2'4 [B] 79-2212
ISBN 0-394-50838-3

INTRODUCTION

Charles Marion Russell was born outside St. Louis, in Oak Hill, Missouri, on March 19, 1864. He arrived in Montana four days short of his sixteenth birthday and died there in Great Falls forty-six years later. Those years spanned a period of enormous change in the West, and Russell's artistic importance resides in his record of life before that change, and his skill in translating his own sense of loss into paint, clay—and words, as we shall see.

Charlie Russell grew up in the years after the Civil War when the West loomed large in the American imagination. As Charlie roamed the family property on his pony practicing Indian war whoops, or haunted the St. Louis river front yearning to join the men leaving on steamboats for fabled destinations far up the Big Muddy, he dreamed the dreams of every boy captive to the spell of the West. But unlike most, he lived out his youthful fantasies and made them his life.

His desires clashed with his parents' expectations of him—a good education and an eventual management position in the family-owned Parker-Russell Mining and Manufacturing Company. In 1879 the Russells sent him to a military boarding school in New Jersey, but even this discipline didn't work. In resignation the Russells gave Charlie a special sixteenth-birthday present: permission to go West with a family friend. Perhaps a summer on a sheep ranch in Montana would knock some sense into his head.

The Russells were right in one respect: Charlie did not take to sheep. A careless shepherd at best ("I'd lose the damn things as fast as they'd put 'em on the ranch"), he was fired from his job. But the land itself—the remote, still-undeveloped Judith Basin of central Montana—already possessed him. Cut loose, he drifted into an acquaintance with a professional meat hunter, Jake Hoover, and spent a year and a half

as his assistant, soaking up lore about Indians, animals, and Montana's past. Life could not have been better.

Charlie's reputation had been sullied by the disgruntled sheepmen who first employed him. But given the opportunity to wrangle horses on a cattle drive in 1882, "Kid" Russell proved himself to the satisfaction of the trail boss and was subsequently hired on by the Judith Basin spring roundup when a night wrangler was fired and no experienced replacement could be found. Despite one puncher's prediction that with Russell minding the herd "we'll be afoot in the morning," Charlie did his job and for all but one of the next eleven years he "sung to the horses and cattle." The wrangler was low man in the cowboy pecking order, but the position suited Charlie. He took advantage of the long days to observe other cowboys at work. He claimed to be "neither a good roper nor rider" himself, but he took pride in his record: "I worked for the big outfits and always held my job."

He arrived in Montana just four years after Custer's fatal stand on the Little Big Horn and was still riding the range when Sitting Bull was shot to death and the last resistance of the Plains tribes was finally crushed by the white man. Even as Charlie rode, relishing his cowboy freedom, things were changing around him. The bitter winter of 1886–87 put a damper on what had been a booming business and foretold in stark terms the end of the cattle industry's dominance on the Plains. Charlie, who was passing the winter on the O. H. Ranch, made a sketch of a gaunt, pathetic cow drooping in the snow. Sent in reply to a letter from the owners inquiring after the condition of their herd, the picture gained lasting fame as *Waiting for a Chinook.*

Besides natural disaster, the Basin had been altered by man. The cattle industry brought the railroad, and the railroad brought the settler.

By 1889 the Basin was crowded to Charlie's way of thinking, and he was glad to trail the herds north to the Milk River country below the Canadian border, where cattlemen could still find free grass for grazing. But there was no escaping progress, and the cowboy way of life was over for Charlie Russell after 1893. It was time to commemorate what used to be.

During his days on the range Russell had seldom been without a pencil, a few brushes, and some paints. He had established a local reputation as the eccentric cowboy who loved to draw, and a few of his works had been reproduced nationally. More than once he had tried to make a living painting, but had always concluded that he would "rather be a poor cow puncher than a poor artist." Now art was to become his livelihood—and his means of supporting a wife. In 1895 the thirty-one-year-old ex-cowboy met a pretty young girl from Kentucky named Nancy Cooper and his carefree, hard-drinking bachelorhood drew to a close. Nancy, seventeen at the time and the product of a broken home, had been taken in by a family Charlie knew in Cascade, twenty-five miles up the Missouri from Great Falls. Russell dropped in to visit, and Nancy years later recalled her first impressions of him: "The picture that is engraved on my memory . . . is of a man a little above average height and weight, wearing a soft shirt, a Stetson hat on the back of his blonde head, tight trousers, held up by a 'half-breed sash' that clung just above the hip bones, high-heeled riding boots on very small, arched feet. His face was Indian-like, square jaw and chin, large mouth, tightly closed firm lips, the under protruding slightly beyond the short upper, straight nose, high cheek bones, gray-blue deep-set eyes that seemed to see everything, but with an expression of honesty and understanding. . . . His hands were good-sized, per-

fectly shaped, with long slender fingers. He loved jewelry and always wore three or four rings. They would not have been Charlie's hands any other way."

Russell, in turn, obviously was infatuated with Nancy. He had been a maverick long enough and was ready to settle down. On September 9, 1896, they wed.

Nancy came from simple stock. Her education was minimal, her face round and sweet. But there was a lump of iron at her core, and she was possessed of a driving ambition. Before she was done she had made her husband the most spectacularly successful American artist of his time. Charlie had always been profligate with his talents and generous to a fault. Paintings now worth thousands went to pay bar bills and grocery orders. When Nancy took over the family's financial affairs, things began to change.

Success did not come easily. Tales abound of these early years when Russell's marketability had yet to be proved. With a deep breath and a hard swallow, Nancy sallied forth, demanding prices that caused her husband to shake his head in dismay. And, of course, Nancy began to get what she asked, so she just kept on asking more. Finally, a one-man show at New York's Folsom Galleries in 1911 marked Charlie Russell's coming of age in the big-time art world. Major exhibitions followed in Calgary, Winnipeg, and London, establishing Russell as an international figure. In managing Charlie's career, however, Nancy exerted control over his time and his relationships that remains controversial to this day and has left her with a reputation ranging from savior to shrew.

Russell had a magnetic personality. He warmed to strangers slowly, although he liked most people and was in his own words "what is called

a good mixer." He was known as an authentic Old West character. His refusal to abandon such vestiges of his cowboy days as Stetson, sash, and boots was one mark of his peculiarity. Charlie, in turn, unquestioningly accepted the right of others to be different. He did not presume to be their judge, and those he counted as his friends ran the gamut. Nancy recognized her husband's devotion to the "bunch" who frequented the saloons and cigar stores scattered along Great Falls' Central Avenue. At the same time, she could hardly approve of them. They seemed crude and obnoxious to her—barflies and hangers-on, better-forgotten reminders of Charlie's misspent youth. They could not further his career since they could not afford his prices, and they wasted precious hours that might more profitably be spent at the easel.

Under Nancy's stern regimen, Charlie arose before sunrise each morning, cooked breakfast for himself, fed his horse, then entered his studio. When he closed the door behind him, he closed out the present and walked into the past. Here in his own log-cabin domain, built in 1903 next to their white frame house, he was at home, surrounded by the memorabilia of a lifetime. Each item contained a story and a memory. Yet the studio was no dusty museum. It was a man's world, a place where, as he told Nancy when it was built, "the bunch can come visit, talk and smoke, while I paint."

Russell was an intuitive painter. When problems arose he improvised solutions. When he found himself stymied by "some anatomical point" in an action painting, he whipped off his shirt, stood before a mirror, and twisted his arms or torso into the desired position. He also was a magician with beeswax and often visualized action in small, three-dimensional figures. Many of his contemporaries considered him a more talented sculptor than painter. Between 1904 and his death, Russell

had fifty-three subjects cast into bronze. He always had a lump of wax with him, and was so facile at modeling that he could shape a miniature animal in his pocket while engaged in conversation.

As a storyteller in paint, Russell drew continually upon his store of personal experience. Because he had lived so much of the western adventure in its waning years, it has become customary to speak of his subject matter and accuracy rather than his artistry. But a contemporary critic was right in noting that Russell was not so much "a painter of stern realism" as "a delineator of the poetical." Russell created his art out of his own deep feelings about the West that was, and the passing years have served to confirm that he struck a responsive chord in countless others.

Russell's character was formed by his years on the range. His humor was earthy, frequently bawdy. Some of his best stories never made it between the covers of a book, though a few of the watercolors he dashed off for the saloon trade survived despite Nancy's attempts to get her hands on them. Nevertheless, the affinities between Russell and his cronies were less remarkable than the differences. After all, Charlie did paint for a living, though some old friends deemed it "a foolish occupation." He had quit drinking and he would not kill for sport. Most remarkably, he was a vigorous champion of the Indian. While most of his Montana contemporaries subscribed to the frontier maxim that the only good Indian was a dead one, Charlie almost from his first contact with the Plains tribes formed an abiding admiration for them.

In Russell's declining years his palette grew even brighter. Color took precedence over exacting draftsmanship and polished execution. Story yielded almost entirely to mood. Indians still watched from windswept hilltops in his paintings, but now they seemed content to

bask in the glow of the sun with nothing more pressing on their minds than the enjoyment of the day's fading warmth. Cowboys rode out to do their chores with the sky in flames behind them. The nostalgia, the longing for the old days, was palpable.

Shortly before midnight on October 24, 1926, Charlie Russell died of a heart attack. His host of friends converged on Great Falls for the funeral. Horace Brewster, Charlie's first roundup boss, told the papers the story of how Kid Russell became a cowboy, and added a touching testimonial: "I've known him ever since, for forty-four years, in sun and shade, and he was sure for his friends, and as white a guy as ever came down the trail. He never swung a mean loop in his life, never done dirt to man or animal, in all the days he lived."

Even before Charlie became prominent, recipients of his letters often saved them. A surprising number survives—letters sent to cowboy pals who accepted "Russ" as one of their own yet always knew he was a little special. Of course, many more of the letters written after he had become a famous artist are extant. Those fortunate enough to get them kept them, and Charlie also wrote more letters in his later years. He generally confined himself to writing personal friends, although it is clear from his letters that he was usually well behind in his replies. But, as this collection attests, Russell "paper talk" was worth waiting for.

Today most of Russell's letters are in the hands of private collectors and public institutions, though a few have been passed down in the families of the original recipients. There is also an alarming number of forgeries floating around, the flotsam on the current wave of interest in western art that has sent prices for even the smallest reminder of Charlie Russell sky high. The letters in *Paper Talk* are the real thing and like all of Charlie Russell's work, it should be added, inimitable.

Brian W. Dippie

FRIEND PONY, *May 14, 1887–89*

Charlie Russell's letter to Friend Pony, an otherwise unidentified cow-boy, may have been written as early as 1887. The twenty-two sketches that accompanied it included two apparently depicting the hard winter of 1886–87 that inspired *Waiting for a Chinook*, Russell's haunting watercolor of an emaciated cow that won wide acceptance as the perfect pictorial representation of a devastating experience for Montana's range-cattle industry. Granville Stuart, manager of the Pioneer Cattle Company, claimed that sixty-six percent of the company's herd per-ished over the winter; the next spring the remnant was moved across the Missouri onto the Milk River range. But Stuart had had enough: "I never wanted to own again an animal that I could not feed and shelter." The great days of the cattleman in Montana were coming to an end even as Russell pondered his own future. He had exhibited an oil at the St. Louis Art Exposition in 1886, and was beginning to receive occasional mention in Montana newspapers. But it was a long time after *Waiting for a Chinook* before he made any money painting pictures, and on the theory that he would rather be a poor cowpuncher than a poor artist, he continued to wrangle horses and cattle through 1893. (Since his wages for the fall roundup of 1884 amounted to just $84, Charlie could not be accused of setting his sights too high!)

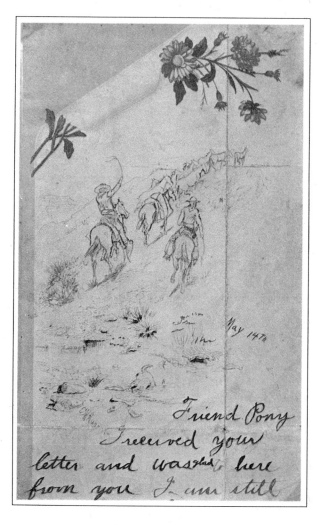

Friend Pony
I received your letter and was glad to here from
you I am still in Montana and still working on
the range we are at present bissy gathering
horses for the spring youndup the cattel have all
been driven north to milk rive [Milk River] and I
leave for their in a fiew days it is a pritty good
cow Country the fellow that told you I was
sketching for a Magizane was misstaken as I have
been on the range all the time I have tirde
several times to make a living painting but could
not make it stick and had to go back to the range
I expect I will have to ride till the end of my days
but I would rather be a poor cow puncher than a
poor artist I send you som sketches by this
mail well old boy there is nothing to wright about
and as you know I am a very poor wrighter I will
close hoping to heare from you soon
I remain your Friend
C. M. Russell
Utica Mt
Furgus county

13

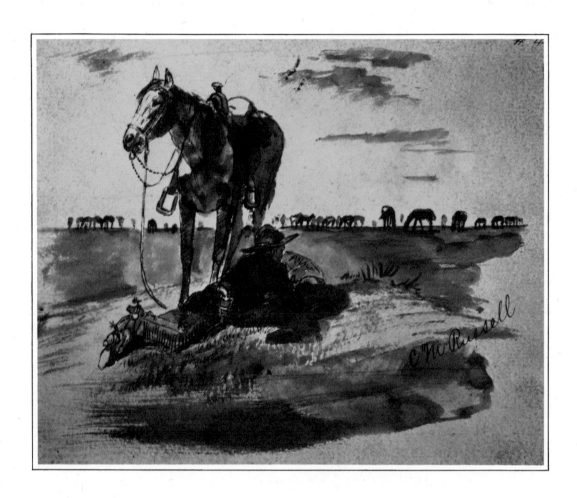

Three of the sketches sent to Friend Pony
Five of the sketches Charlie enclosed were Indian subjects, one was of a herd of antelope, and the rest depicted incidents in the cowboy's life. The three reproduced here show a hapless puncher taking a bruising spill, a lone rider fighting his way through a blizzard, and a cowboy reading in the shade of his horse—perhaps Russell himself.

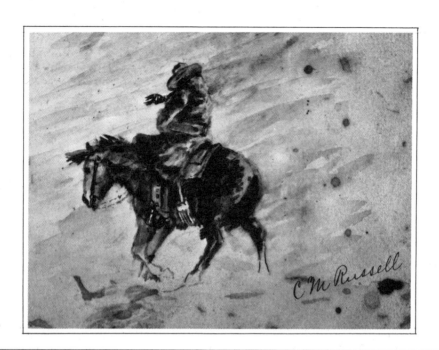

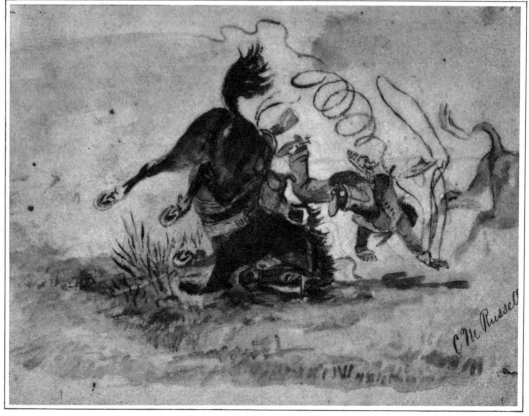

Cowboy Camp during the Roundup

Charlie painted this two-by-four-foot oil while he was still a working cowboy in the Judith Basin. It caused comment in the local press and was reproduced in the Helena *Journal* in 1891, making it, along with *Waiting for a Chinook,* the most important of Russell's early works. *Cowboy Camp during the Roundup* was done for James R. Shelton, proprietor of one of Utica's four saloons, which stand out prominently in the background. In it, Charlie carefully delineated each horse and rider in the 1886 roundup, and forty years later one of the cowboys who was there could still name every individual in the painting. On the right, trailing off into the distance, Charlie showed the horse wranglers at work—a scene that he isolated at the top of his letter to Friend Pony. Since Charlie liked to invent his own nicknames for friends, it is possible that "Pony" was the wrangler identified as Kid Mussy in the painting.

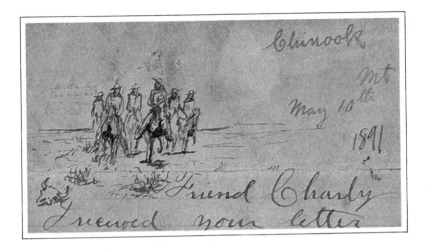

FRIEND CHARLY, *May 10, 1891*

To Russell's way of thinking, the Judith Basin was washed up as prime cattle country by 1891. In this letter to a cowboy friend (possibly Charley Colthay, who represented the B-D outfit on Russell's first roundup and spent a couple of nights teaching him the ropes as a wrangler), Russell recounts the changes that have overtaken the Basin since the mid-1880s and covers in a few cryptic sentences an experience that had a lasting impact on his life and art. After a lazy year with some friends in southern Alberta, Charlie passed the winter of 1888–89 in a camp of Blood Indians. It cemented his interest in the "real American," and filled his mind with pictures that made him in the years to come as gifted an interpreter of the old-time Indian as he was of the cowboy. He formed a lasting respect for the Indians that set him apart from most of his cowboy contemporaries. "I don't know much about them even now," he humbly remarked in 1917, "they are a hard people to 'sabe.' " What he did know was that he admired them, and he joined them in mourning a lost way of life.

Friend Charly

I received your letter and was glad to here from
you I left the Judith country like all cow
punchers I followed the heards of cattel as all
the big heards have moved out across the Missouri
river I am now on Mik [Milk] river this is a
good cow country and as the gater part is bad
lands and cant be setteled it will last I have
romed around a good dele since I saw you I
went out north a cross the line and lived six
month with the Blackfeet I had a pritty tough
time I still have my sam horses Monty and
Eagel Monty lookes the same as ever I still
night herd and often in the long nights last fall I
thought of you well I suppose you want to
know abot the boys poor Ed is dead he died
a year ago I have lost two brothers since I saw
you it is pritty hard but we all have to stand
such things in life Jim Sheldon has left and all
the cow punchers are in this county I was
suprised to here that you were married but think it
was the best thing you ever did and hope you will
settel down and live like a whit man I never
expect to be that lucky I expect if I ever get
married it will be to this kind [squaw] as there is a
grat many fo [of] them here and I seem to take
well among them I had a chance to marry
Young Couses daughter he is black foot Chief
It was the only chance I ever had to marry into
good famley but I did not like the way my
intended cooked dog and we broke of our
engagment well old boy I cant think of any
thing more to write about I am going out on the
roundup the 20th but my address will be
Chinook Choteau County hoping to find
you well I remane as ever your friend
C. M. Russell

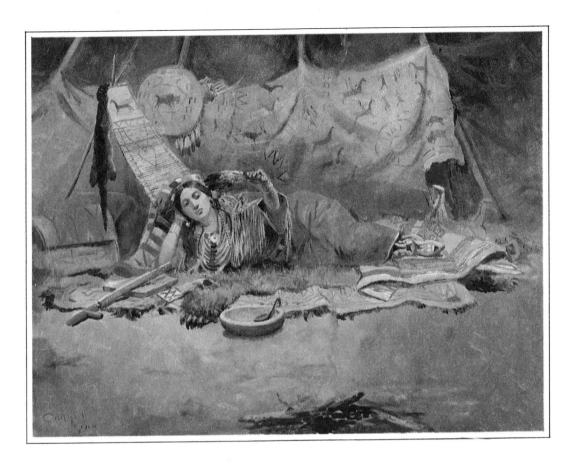

Keeoma, *oil, 1896*

A romantic legend persists that over the winter of 1888–89 Russell became romantically involved with a chieftain's daughter and seriously considered marrying her and settling down permanently among the Bloods. Though he joshes about the idea in his letter to Friend Charly, he may have contemplated it. "There was plenty of cowpunchers . . . who were not ashamed to marry an Indian girl," Russell's cowboy friend E. C. ("Teddy Blue") Abbott wrote years later. "You couldn't blame us . . . and some of these young squaws were awful good-looking." Russell most emphatically agreed. In the 1890s he painted dozens of studies of young Indian women, including at least one exquisite nude. All attest that he found them abundantly attractive—though the famous series of *Keeomas* he executed in this period were probably posed for by his own wife Nancy.

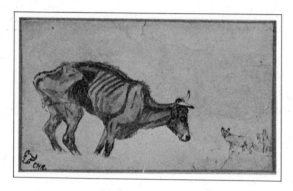

This is the real thing painted the winter of 1886 at the OH ranch C M Russell

FRIEND JESS, *1896–97*

Jesse Phelps, described as a good stock hand by a Montana acquaintance, was co-owner of the O. H. Ranch in the Judith Basin in the 1880s. Charlie, improvident as usual, passed most of the winter of 1886–87 at the O. H. and was on hand when Phelps received an anxious letter from a Helena businessman who with a partner ran 5,000 head of cattle nearby. What was the condition of their herd? While Phelps struggled to find the right words to tell them that their herd had been decimated, Charlie dashed off *Waiting for a Chinook*. It spoke for itself, and Phelps let it serve as his reply. While the incident depicted in Russell's letter to his old friend has not been recorded, the sketch shows two men—presumably Phelps and Charlie—aboard an O. H. wagon watching calamity befall a companion. Though the one page of the letter extant is undated, it was written long enough after the incident for Charlie to have forgotten a few details, but not his fondness for the open range days in the Judith symbolized by the cluster of brands.

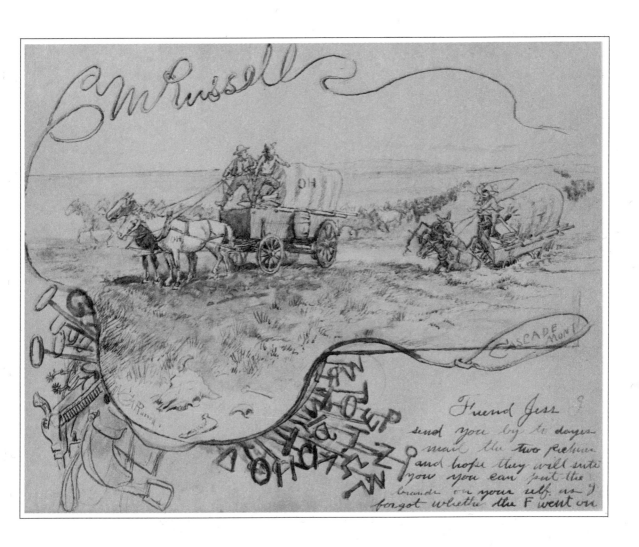

Mamie, *oil, ca. 1895–96*

Charlie Russell was infatuated with Nancy Cooper (or Mame, as he called her) from their first meeting in Cascade in October, 1895. The story goes that he painted this portrait of "Mamie" shortly after they met; certainly his infatuation shines through. When it came time to pop the big question, however, Charlie was backward about coming right out and asking Nancy to marry him. Instead, he talked obliquely about his plans for their future together, and Nancy got the impression that he was proposing they live together without benefit of clergy. Before she could give him a full piece of her mind, Charlie hastened to assure her that his intentions were strictly honorable. The date was set for September 9, 1896. As it drew near, Nancy took ill and was hospitalized in Great Falls for a brief period. Since Charlie was living in Cascade by then, their separation occasioned the earliest correspondence extant between the Cowboy Artist and his bride-to-be.

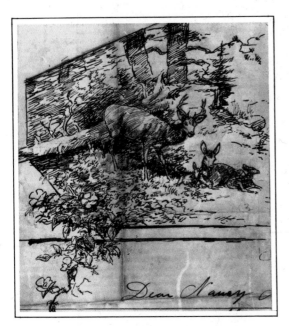

Dear Nancy I reached home all ok and every one was glad to here that you were better I hope you got your tooth bruch all right I sent it up by the expressman Josy is doing the cooking and we are getting along nicely altho we are all lonsum with out you especially Me Vince Fortun is going to the Falls tomorrow and sayes he will go and see you inclosed you will find $5 I thought you might need it I got your ring all right but left it at Egloffs to have our initials put in it I think you will like it Maggy will be here to morrow well Nancy as there is no news to to tell you you I will close with much love and xxxxx I am yours truly C M Russell
I will send the Picture to morrow

DEAR NANCY, *August 20, 1896*

Charlie, who was about as reliable with dates as with his spelling, evidently returned to Cascade on the 20th after a visit with Nancy in Great Falls. He had bought her wedding band by then and was having it initialed at Egloff's Jewelry. And he had painted a little scene for her of a doe, a buck, and their fawns—a domestic idyll expressing his dreams of their future together.

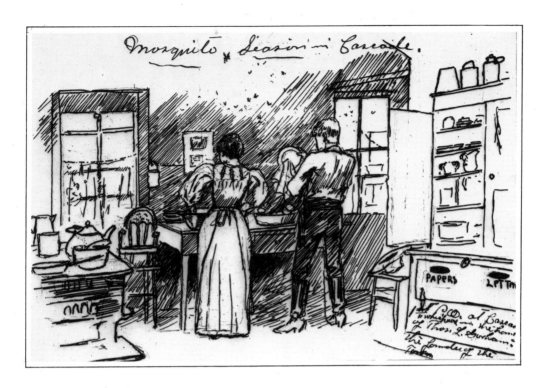

Mosquito Season in Cascade, *pen and ink, ca. 1896*

After Charlie and Nancy were married, the wedding guests ate ice cream and cake "and Charlie and Mamie went on their honeymoon. It was walking hand in hand about three hundred feet to the little frame shack which had been fixed up for their first home." Humble enough to bespeak their stringent financial circumstances, it was described by a visitor as "a little one-room building with a lean-to kitchen." But the shack was home to Charlie and Nancy, and in this sketch the former cowboy recorded his adjustment to married life.

Charlie had not yet proved that his art could adequately support himself, let alone a wife. He was fourteen years Nancy's senior, and had lived the foot-loose, free-loving life of a bachelor cowboy and artist since he was sixteen. At thirty-two he might well be set in his ways, and for all his charm the married folks he knew were unsure about what kind of family man "Kid" Russell would make. The passing years would provide the answer. Even as their life underwent enormous changes, Charlie and Nancy remained a devoted couple.

27

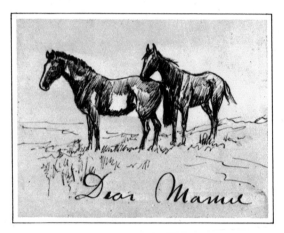

Dear Mamie I hope you got my last letter and the picture all right I know you are very lonsum but we will make up for that when you come back we are getting along all right but we all miss you very much and you know I do but I am so glad you are in good hands you must not come back till you are well and strong if you get to lonsum let me know and I will come down and stay till you get well I will drop you a fiew lines every day and let you know how we are getting along we have got the house all stratened up now and it looks as well as ever Josey Maggy and I had quite a time hanging the pictures in those old places well nancy I will close for this time with love yours truly
C. M. Russell
Josy and Maggy Effey Nelly send love we expect Mrs Roberts tomorrow but we are not sirten Mr Roberts says he will write you tomorrow

DEAR MAMIE, *August 24, 1896*

Through all their years together, Nancy was rarely absent from Charlie's side. He went on regular outings with the boys, often for a few weeks at a time. She, in turn, was away infrequently, and whenever she was gone, Charlie was quick to confess that he was "lonsum" without her. "If the hive was all drowns [drones] thered be no huny," he maintained. "Its the lady bee that fills the combe with sweetness its the same with humans if the world was all hes it would sour an spoil."

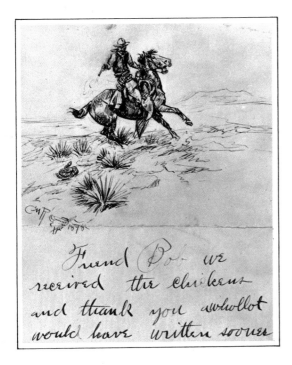

Friend Bob we received the chickens and thank
you a whollot would have written sooner
but have been out of town my Father is
here we have just returned from loging creek
we caught all the fish in that country I dont
think with best regards to yourself and family
 yours full of chicken
C M Russell

FRIEND BOB, 1898

At a time when business was slow and money hard to come by, the gift
of a few chickens from Bob Thoroughman was much appreciated—if
only as a change from the fish diet Charlie's letter implies. The early
years were a constant financial struggle for the Russells. Even the move
to Great Falls made no appreciable difference in their fortunes. One
problem was that Charlie's prices were unrealistically low. In 1897,
three black-and-white illustrations for a book brought only $30, while
a contract signed with *Field and Stream* called for a payment of just $15
each for twenty black-and-white oils and $50 for twenty pen-and-ink
sketches. At these rates even a superhuman increase in Charlie's
productivity would not bring prosperity. But a year later, at the sug-
gestion of Charles Schatzlein, the owner of a Butte paint store who
had been acting as Charlie's agent, Nancy began to assume the business
end of her husband's career. It was a long trek from free chickens and
a shack in Cascade to new Lincolns and extended annual vacations in
southern California, but Mame's drive got them there.

Bronc in Cow Camp, *oil, 1897*

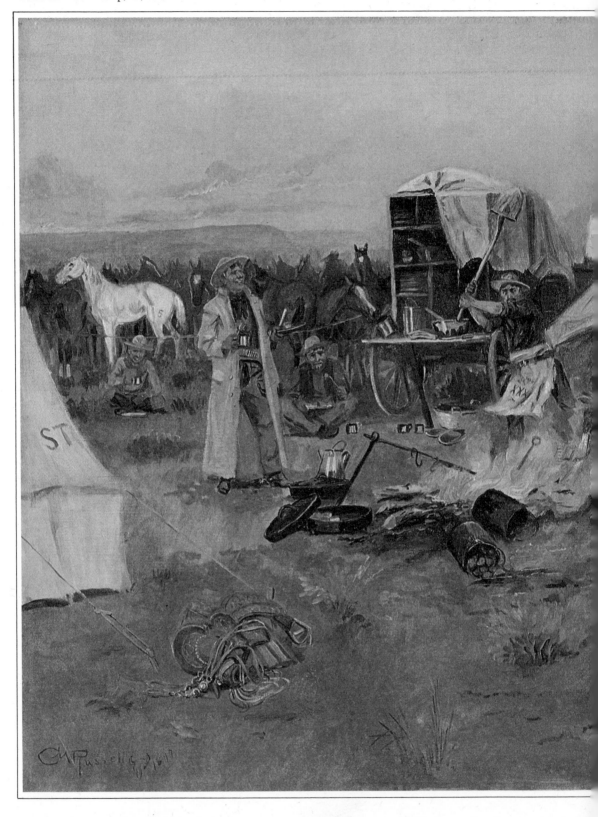

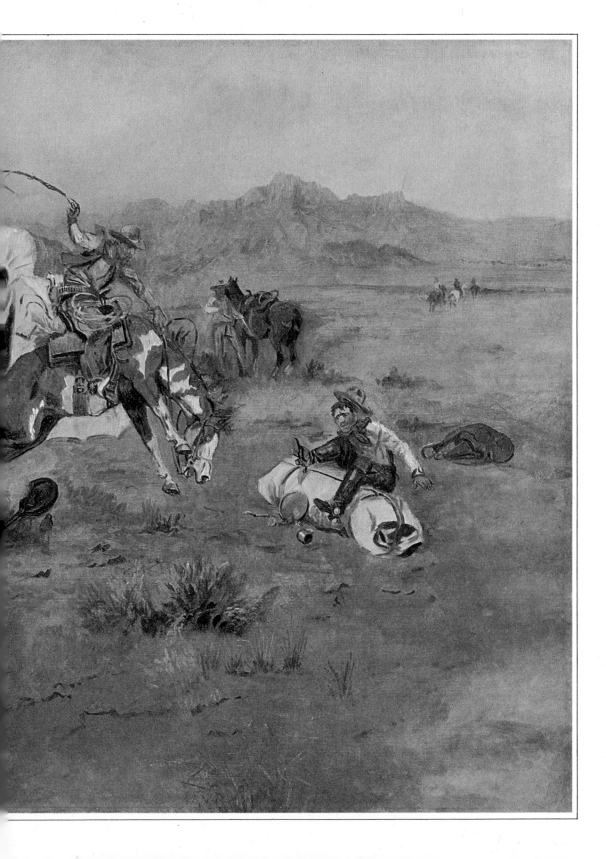

Bronc in Cow Camp

Friends like the Thoroughmans were worth more than a thank-you letter, and Charlie repaid their kindness in the only coin he had. He gave Bob Thoroughman three paintings, including this 1897 version of what became a popular Russell subject, *Bronc in Cow Camp.* The oil shows Thoroughman starring in a drama he would rather have avoided. The setting was the Big Hole country where, in 1879, Thoroughman was roundup captain for Sands and Taylor. His horse, an Indian pinto, was an ornery creature at the best of times and, from the looks of Charlie's painting, downright treacherous when the mood hit him. A friend who watched Russell at work on the oil remembered that he had the scene "clearly mapped out in his mind" and was thoroughly enjoying recording his friend's discomfiture for posterity.

FRIEND BILL, *April 26, ca. 1899*

In the early 1890s Bill McDonough and Charlie Russell worked the range together in the Milk River area and kicked up a little hell in Chinook. "We were all young and full of fun," one of their friends recalled, "but some of the stunts look better now, than they did then, to those on whom our little jobs were pulled off." Charlie himself had a favorite story about the time Kid Price got an invitation to dinner from one of Chinook's painted ladies, who promised to cook a royal feast for the Kid's cowboy cronies if he would provide the chickens. "He got the chickens and a splendid dinner with all the 'fixin's' was the result," Charlie remembered. "She bragged about what fine fowl they were—that she had never eaten better—and well she might, for when she went to feed her birds the next day they were gone."

The little sketch on Charlie's letter is an affectionate tribute to the "good days in Chinook" when the town, like Charlie and McDonough, was younger and wilder.

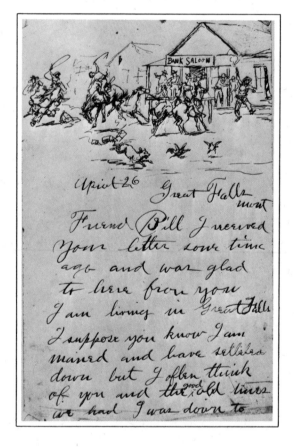

Friend Bill I received your letter some time ago
and was glad to here from you I am living
in Great Falls I suppose you know I
am maried and have settled down but I
often think of you and the good old times we
had I was down to Chinook 4 years ago I
have seen very few of the old boys since I am
doing very well here I am glad to here you are
doing well I hope if you come up in this
country you will come and se us my wife is
always glad to se my friends with best regards
to yourself and Dad I am your friend
C M Russell

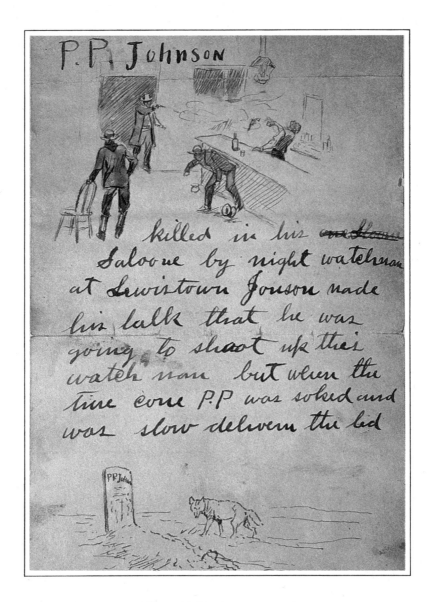

Portion of a Letter to Harry T. Duckett, *July, 1901*

In July, 1901, Charlie sent a unique letter to Harry T. (Tom) Duckett, who had quit cowboying in Montana and moved to California to become a newspaperman. On separate sheets, Russell recounted the fate of eleven mutual acquaintances, seven of whom met violent ends, one on the job and the rest in a hail of lead. P. P. Johnson was one of those who died with his boots on.

Illustrated Envelopes

During his early years as a professional artist, when success lay in the future and time was less precious, Charlie often illustrated the envelopes he mailed to his friends. Charles Schatzlein got a sketch of Russell handing a letter to an Indian rider with the message "Take this to the Butte of many smokes," while Senator Paris Gibson, founding father of Great Falls, got a party of warriors trailing him to the nation's Capitol. The examples reproduced here are typical.

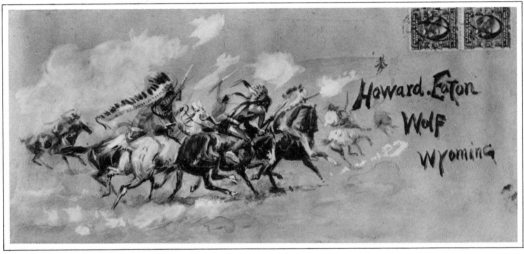

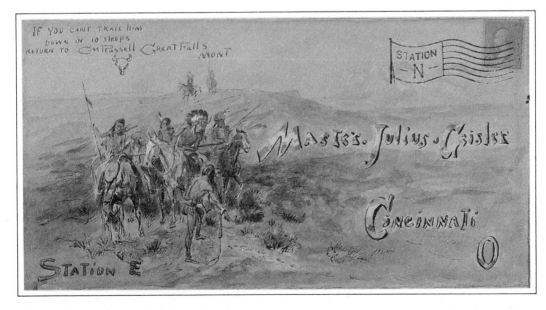

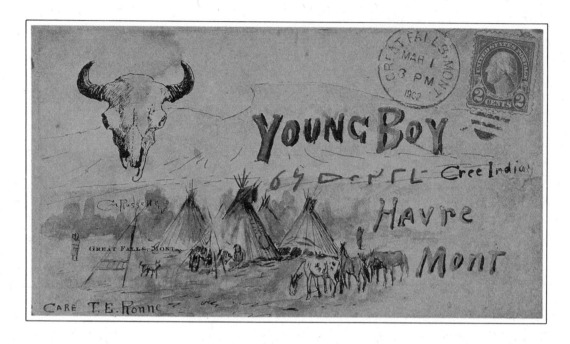

FRIEND YOUNG BOY, *March 1, 1902*

Young Boy, Charlie's closest Indian friend, was the brother of a Cree chief. He arrived periodically at Charlie's studio to ask for a loan. Sometimes he was specific about when he would repay it; other times he would not commit himself to an exact date. Either way, Young Boy always honored his debts, and he repaid his artist friend's kindness with many gifts over the years, including a medicine bundle sack, beaded arm bands and cuffs, and the shield referred to in this letter. Young Boy was Nancy Russell's first caller following Charlie's funeral. After offering his condolences, he pressed his hands against his chest and exclaimed with great emotion, "He was my friend." Then he turned and walked out.

The sketch beneath Russell's signature represents his Blood Indian name, Ah Wah Cous, the Antelope.

38

Friend Young Boy I

received the shield and
pictures they wer all fine
and I thank you verry
much I will paint
your picture as soom
as I can

Your Friend
C M Russell

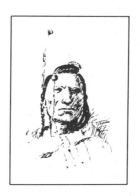

Young Boy, *oil, ca. 1896*

Young Boy was Charlie's favorite model. Jessie Lincoln Mitchell, a neighbor and a talented sculptor herself, remembered walking into Russell's log cabin studio one day and finding Young Boy there, "tall, straight and immobile," posing for a painting. As he worked, Charlie remarked: "If you ever want a good model you can have Young Boy. There's no better." Young Boy glanced at Mrs. Mitchell but otherwise did not move. "I heard the big clock on the wall tick off the time, but that was the only sound in the studio." Suddenly, Russell "leaned back in his chair and let his hand—the one holding the brush—rest listlessly on his knee. He sat there some time studying the picture. Then he leaned forward and dipped his brush in scarlet paint and gave one dab to a figure; it sprang into view like magic. Charlie turned and smiled at me. Not a word was spoken. We both felt the satisfaction of the moment." Though Young Boy's features often appeared in Russell's work, Charlie never did a finer portrait of his friend than this excellent early study.

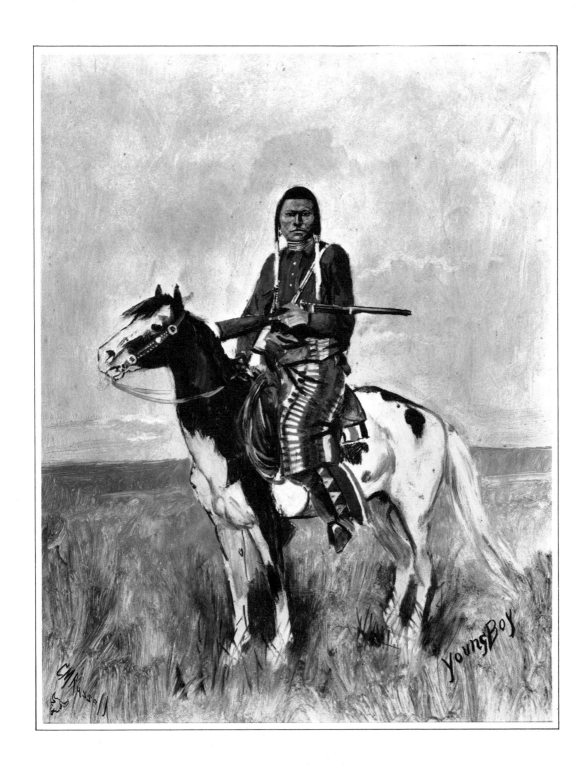

a sentinal who is as motionless as the rocks about him but his

bad eyes see all for miles not a seek on the planes escape his keen sight he will read the puffs of a signal smoke miles away as his whit cousin would a book if a distant hunds is suddenly disturbed while grasing he studies out the cause if the wild goes

DEAR MR. KERR, *March 21, 1902*

George W. Kerr, the recipient of this unusually long letter from Charlie, was a St. Louis neighbor of the Russells and a distant relative through marriage. Charlie knew the crusty ex-Confederate officer well enough to present him with the painting described in this letter, *Dangerous Ground,* showing a Kootenai hunting party encroaching on Blackfoot territory. Subsequently, Charlie sold Kerr an exciting action painting, *Counting Coup,* depicting a clash between Sioux and Blackfoot that Russell had heard about during his winter with the Bloods. Sales such as these outside Montana not only enriched the family coffers but helped broadcast Russell's name at a critical juncture in his career when he was just beginning to attract national notice.

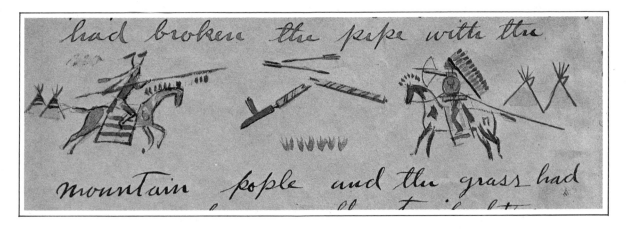

had broken the pipe with the

mountain pople and the grass had

Dear Mr Kerr

I sent som pictures to Father one among them for
you called dangerious ground it represents a
kootenai hunting party In the old buffao days
the kootenai who are a mountain tribe often
invaded their enemys county for buffilo the
Black feet live on the planes and are a verry strong
warlike people who as the Indian would say had
broken the pipe with the mountain pople and the
grass had growen long in the trail between their
fires so when the kootenai hunted in the
Blackfoot county cautiously dismounting and
walking beside his pony when in high or open
country on these occasions they went in small
partys generly using dark Poneys if white the
owner threw his robe over him they traveled
very slow allowing there animels to grase now and
then imitating as nere as possible the movments of a
heard of old bulles all glittring orniments were
hidden even the lance was carred point down for
fere its frash in the sun might betray them in old
times when buffilo were plenty old bulls were not
hunted as nether there meet or hide was good as
soon as a bull looses his fighting quality he is
whiped out of the heard by the younger set and as
misiry loves coumpiny these old fellows gether in
small bunches away from the main heard. the
Indian is a great student of nature and knowes her
well it takes a thief to catch a thief it also
takes an Indian to fool an Indian. he knows that
some far off butte holds a sentinal who is as
motionless as the rocks about him but his beed
eyes see all for miles not a s[p]eck on the planes
escape his keen sight he will read the puffs
of a signal smoke miles away as his whit cousin
would a book if a distant heard is
suddenly disturbed while grazing he studies out
the cause if the wild goos circles his
feeding ground an failes to light it is man that
has caused it nature is his mother and
she talks with her child ask aney prairie or
mountain man what these spots on the
planes [sketch] are and he will tell you horse men
but point these [sketch] and it will puzzel even an
Indian to tell whethur they are buffilo cattel or
horses unless it is in there movement the horse
is much quixker in his movements than other
animals of his size but put a man at his side
who knows his business an it will kepp you
gussing well Mr Kerr as I am a verry poor
writer I will close if you ever come to this
country an cut my trail do not pass my camp
my lodg is yours an the pipe will be lit for you

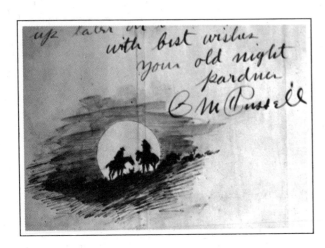

Friend Charly
I send you by express two pictures I thought it
would be a good idea to make a historical
string of sketches so have started in on earley
days but will come up later on the cow puncher
with best wishes your old night pardner
C M Russell

FRIEND CHARLY, 1903

The recipient of this letter has been identified as Charley Joys, an old cowboy friend of Russell's who had gone into the publishing business. Possibly he was the Charles M. Joys whose father was president of Wright & Joys Co., printers, in Milwaukee. The two black-and-white watercolors Russell sent with his letter were intended to be part of an "historical string of sketches." Charlie provided information about both of them, suggesting that Joys was planning to reproduce them along with a descriptive caption incorporating the artist's comments. *The Enemy's Country* and *Men that Packed the Flintlock* illustrate a West that Russell never knew firsthand but always cherished, a West virtually untouched by civilization and thus—to Charlie's mind—still unspoiled.

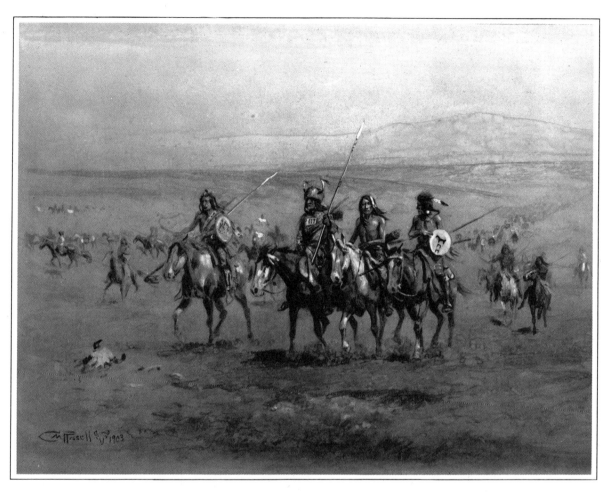

(The Enemys Country)
In old times Indians when on dangerous ground
travieled in this way with strong advance flanks
and rear gard [sketch] for instance Blackfeet
in the Sioux country (Men that packed the
flint lock) trappers in the days [of] Kit
Carson and Jim Bridger

Men Who Packed the Flintlock, *watercolor, 1903*

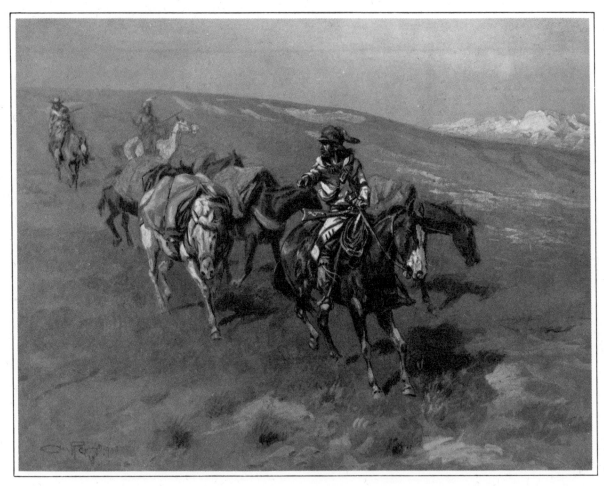

FRIEND TRIGG, *November 10, 1903*

No friend meant more to Charlie Russell than Albert J. Trigg. When they first met in 1891 both were relative newcomers to Great Falls. Trigg, an Englishman who had lived in Canada and Michigan before coming to Montana with his wife and daughter, was the genial proprietor of the Brunswick Bar; Charlie, hoping to leave the range behind and make art his full-time occupation, set up his studio in the rear of the Brunswick. In 1900 the Russells bought a double lot beside the Triggs, and the two families became not merely neighbors but the best of friends. Charlie saw Albert Trigg, who was twenty-one years his senior, as a father figure, and the two visited back and forth "four or five nights every week." Whenever Charlie was out of town, he made certain he got a letter off to his friend.

Many of Russell's letters to Trigg mention visits to big city zoos, but none reports an incident more touching than the story told here of a captive coyote yearning for the plains he will never see again.

James A. Barnard, mentioned in Charlie's postscript, ran the Park Stables where Charlie quartered Monte during his absences.

St. Louis Mo
NO 10 Th 1903

Friend Trigg

I thaught I would write an let
you know I'm still among the
live ones
I have taken in the worlds fair
grounds it is verry grand but
dont intrest me much the
animal gardens which is near
thair is more to my liking

Friend Trigg

I thought I would write an let you know Im still
among the live ones I have taken in the
words fair grounds it is verry grand but dont
interest me much the animal gardens which is
near thair is more to my liking they have a
verry good collection among them a cyote who
licked my hand like he knew me I guess I brought
the smell of the planes with me I shure felt
sorry for him poor deval a life sentence for
nothing on earth but looks and general princepales.
but you cant do nothing for a feller whos hol
famely is out laws as far back as aney body
knowes eaven if he is a nabor of yours If he
could make hair bridles it would bee a hollot easier
but with nothing to do but think of home
its Hell that all
Im stopping with my Folks who live verry neare
the place where I was raised and altho the

49

about 10 quail but as there
is no shooting allowed
that accounts for it
seeing these birds in this
woods reminds me of when
I was a youngster of about 9 winters
hunting with a party of kids
we had one gun this wepon was the
old time muzzel loding
musket there was but one boy
in the party long enough to
lode her with out the ade of

country is much bilt up there is some of the old
land marks left an a little patches of woods
enough to take me back to boy hood days and I
was much suprised the other morning to scare up
about 10 quail but as there is no shooting allowed
that accounts for it seeing these birds in this
woods reminds me of when I was a youngster of
about 9 winters hunting with a party of kids we
had one gun this wepon was the old time
muzzel loding musket there was but one boy
in the party long enough to lode her with out the
ade of a stump or log so of corse he packed the
amuninition an don most of the loding we were
shooting in turns at aney thing in sight well I
kept bellyaking saying my turn an the big kid
saying youl get yours an I did when he loded
for me I remember how the rod jumped clear of
the barel he spent five more minutes
tamping the loade then handing the gun to me
said thair that would kill a tiger an I think it
would if hed been on the same end I was my
game was crows I climed to the top of a
rail fence to get cleane range and then as
the Books say for an instant my hawk eye
mesured the glistening barrel then the
death like stillness was broken by the crack of
my fath full wepon an I kept it broken with
howls for quite a while I just returned
from the country where I been visiting som
of my relations I enjoyed it verry much. the
woods were ablaze with color I eat
possimons an all kinds of nuts they were still a
little green but I tackled them just the same this
country is beautiful all right but I miss the
mountains I cant see far enough I was verry
sorry to here of the smelter closing it must
make it tough for the Falls I often think of the
eavning at your house the fire place magizines
an arguments with Bill Is Jack still with
you do you ever see Olef these days I have
worked this range pritty close an havent found
a camp with a willow seat in it an I shure get
leg weary well Trigg as Im all in I guess Il
close the deal with best whishes to yourself
and famely an same to the boys Your Friend
C M Russell
if you see Jim Barnard ask how Monty
is getting on

a stump or log ⁴ so of corse he
packed the ammunition an don nost
of the loding we were shooting in turns
at every thing in sight
well I kept belly aking saying my turn
an the big kid
saying youl get
yours an I did

when he
loded for me
I remember
ow the rod
jumped clear
of the barel
he spent five
more tamping
the loade

then handing the gun to me said thair
That would kill a tiger an I think it
would if hed been on the same end I was

FRIENDS, *November 14, 1903*

George T. (Cut Bank) Brown, whose later metamorphosis into a successful Los Angeles realtor Russell dutifully reported in his letters back home, was one of the proprietors of The Maverick saloon in Great Falls in 1903. He was a colorful character and something of a fashion plate. But Charlie, in St. Louis to see about having his work displayed at the Louisiana Purchase Exposition the next year, claimed to have Cut Bank beaten by a Mormon block—which was a long way by anyone's standards. This was probably the best known of Russell's illustrated letters during his lifetime, since it was reproduced in newspapers and a national magazine and was later distributed as a print by The Maverick.

St Louis Mo
Nov 14 1903

Friends
I'm in
Missouri

When It comes to
beeing dressy
I'm all there is
to it
I got Cut Bank
Brown beet a mormonbloc
Your friend
C M Russell

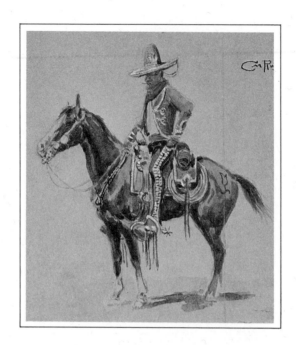

FRIEND BOB, *January 16, 1907*

The Russells visited Mexico in March and April, 1906. As this letter to Bob Stuart, a cowboy friend from way back, indicates, Charlie was duly impressed by his stay on the vast Don Luis Terrazas ranch. He knew that Stuart, a top bronc buster in his prime, would be interested in cowboy fashions south of the border.

In 1906 Russell was still a drinking man and, if the recollections of Thomas Edgar Crawford, another old cowhand, are to be believed, Charlie's stay in Los Angeles on his return from Mexico was one long spree. "He and I had been 'seeing the elephant' on Saturday night," Crawford reminisced, "and decided to go to Pasadena on Sunday morning to see an old cowpuncher who lived there whom we both knew." They never did find the cowpuncher, but they found a party going full-tilt in one of the Pasadena hotels and "it was Monday morning when we got down out of there." Crawford's story may be apocryphal, but Charlie's letter to Bob Stuart affirms that he and at least one former cowboy, Tom Duckett, got together for several "grate old time talks."

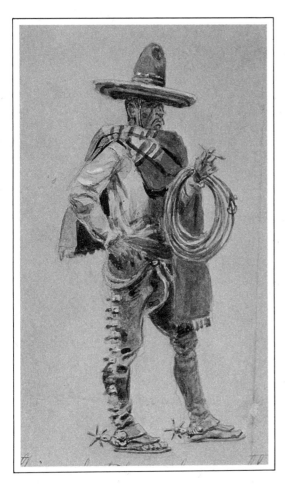

seventyfive thousand calfs last spring besides his cows he ownes thousands of horses and mules. the sketch above showes what a mexicon cow boss looks like he dont run a wagon as they say in this country as in mexico they dont use them his grub an beding is packed on mules an the mules aint over loded there bill of fare is beef beans corn meal an red peper an coffee the bigest part peper that is I think so from some of the feed I got. where everyman wares his own bed like the genletelman to the left there no need for bed wagons this sketch shows the commen vacquaro he gits from eight to ten a month an his grub but as muscal there whiskey is one sent a drink he has a good time one drink of this boose will make a jack rabit spit in a rattel snakes eye an as all mexicons pack knives cow out fits often leave town short handed God knows the boose we got was bad enough but I belive if wed had miscall at the mexicon price with our wages every cow out fit would have needed a hurs in sted of a bed wagon as it was it was bad enough we both know many cow punchers that fell under the smoke of a forty five that are takin there long sleep in a hole on the prary the cattle in mexico ar all spanish long hornes an are shure wild I went to a bull fight in the Sity of Mexico there were seven bulls an forten horses killed it was shure exciten if I was where I cound talk to you I would tell you all a bout it but writing aint my strong holt. on my way back I stoped at Los Angeles Cala an visited Tom Duckett hes working on a news paper I was there two weeks an Tom an I had som grate old time talks well Bob this aint much of a letter but its a dam sight better than you don so as they say in Mexico adieose ah um ah megos with best regards from us both to your self and wife your friend
C M Russell
give my regards to all the old time boys

Friend Bob I received your long letter where you called me a lobster well you old twister Iv been to Mexico since I saw you an am sendin you some sketches of cow people down there its shure an old time cow country I traversed from the northe like to with in a 100 miles of the ismus an never saw a wire its all open range. I ust to think the old time cow punchers were pritty fancy in this contry but for pritty these mexicons make them look like hay diggers. I was on the range of Forasis the bigest cow man in the world it takes a thousand riders to work his country he onely branded

Mexican Rurales, *watercolor, 1906*

Charlie Russell was preeminently the artist-historian of the Northern Plains frontier. Montana was his stamping ground and he rarely wandered astray, though the Southwest continued to intrigue him. On his return from Mexico in 1906, a Los Angeles paper reported that he would "make a series of Mexican pictures when the spirit moves him to do so." Several paintings, including this fine study of the Mexican police, followed over the years. But Russell remained loyal to his own turf and his own life's experience, advising others to paint the cow country of California and the Southwest that they knew as intimately as he knew Montana.

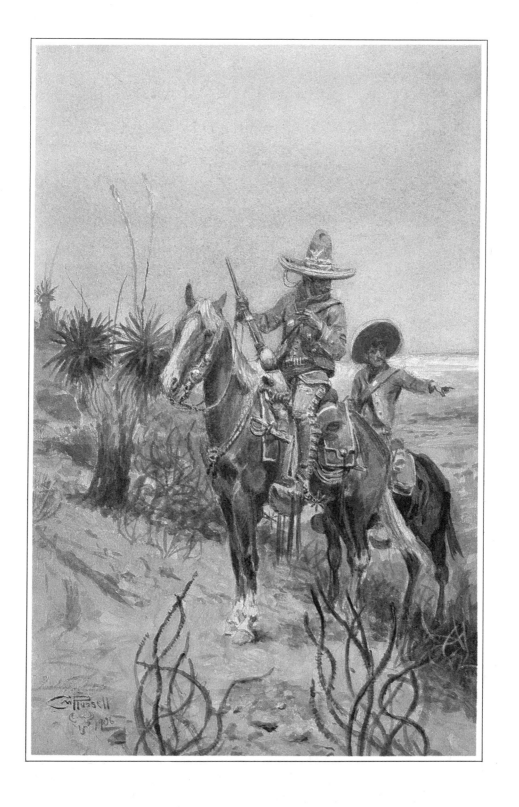

FRIEND SID, *May 3, 1907*

In this letter to Sid Willis and the regulars at The Mint saloon, Charlie joshes about the exalted company he is keeping while in New York City. It is possible that he actually met the fabled William A. Clark about this time, however. Helen R. Mackay, the wife of one of Charlie's major eastern patrons, recalled a story that Nancy liked to tell about an early visit to New York. Clark, a former senator from Montana and the state's richest mining magnate, had built a mansion on Fifth Avenue and was interested in acquiring a few Russell watercolors to decorate its walls. An appointment was set up, and shortly before Clark's arrival Charlie learned that Nancy planned to ask $350 for each painting. As in all such anecdotes, he denounced her "dead man's prices," but to his astonishment Clark paid without a murmur.

Sid Willis, like Bill Rance across the street, was a Great Falls saloon keeper who knew Russell from way back when. Russell and Rance roomed together for a while in the early 1890s, while Willis was a working cowboy and a sheriff in the vicinity of Glasgow, Montana, for ten years before drifting into Great Falls in 1898. After tending bar for others, Rance and Willis eventually graduated to ownership, and their respective emporiums—the Silver Dollar and The Mint—were two of Russell's favorite downtown hangouts. Both men accumulated celebrated collections of Russell art. The Mint collection became the most famous in Montana and today forms the nucleus of the great Russell collection at the Amon Carter Museum.

In this letter to Sid, Charlie has pointedly paired Clark with Piano Jim, a stuttering, henpecked "professor" in one of Great Falls' red-light-district dance halls and a prominent character in some of Charlie's best off-color stories. It was a pairing that would have delighted "the bunch" at The Mint.

May 3d 1907

Friend Sid for fere
you will worry about me
I am droping you a line
I intended leaving here serra
weeks ago but I cant brak
away from Rockeyfeller an his
bunch every time I try an make
a git-away he invites me up
to have crackers an milk
with ~~with~~ him he shure hat
to see me leave John sends
~~sends~~ his regards to the
bunch an wanted me to
remember him to Piano Jim
an W.A. Clark
with best wishes to friends
your friend C.M.Russell

Me an Jack

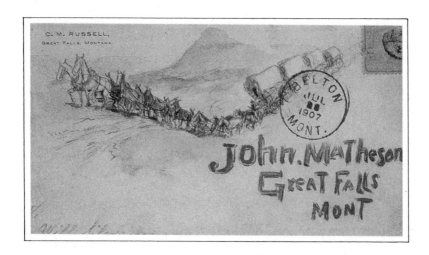

HOW GOOD FREN, *July 28, 1907*

Charlie liked few old-timers more than Johnny Matheson, a freighter who hauled between Great Falls and Lewistown in the Judith Basin. His jerkline outfit, as Russell has depicted it on the envelope, consisted of fourteen horses, three wagons, and a cart. Johnny is riding the saddled wheel horse on the left-hand side nearest the wagon. A native of Ontario, Canada, of Scottish extraction, Matheson had the fierce temper and profane tongue that tradition attributes to the freighter. He was a bachelor and not entirely housebroken—at least, he was intimidated by the presence of women and found the strain of trying to balance a teacup and keep his language polite too much to endure.

Johnny thought Charlie a prince of good fellows. In 1907 he apparently sent him an Indian saddle to add to his studio collection. It is hard to be precise because Russell chose to express his thanks in a thick Indian-English dialect. A possible translation: When Charlie got the saddle, he let some children ride on it, including a little Indian girl about four years old who played Lady Godiva by riding bare-backsided to Charlie's considerable amusement.

CHAS. M. RUSSELL
GREAT FALLS, MONTANA

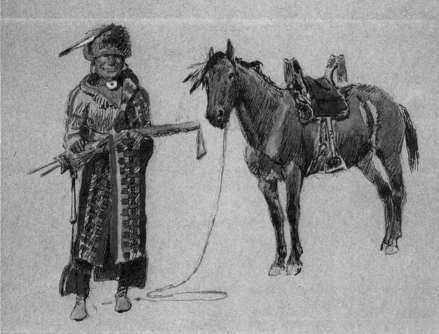

How good Fren
me get it saddle dats a be Dam good one
but you dont said how much
when I get it little people make me heap glad
one these maby so fore squaw little Injun ride
hoss make it me laugh. heap good
long time your Fren
Ah wa caus

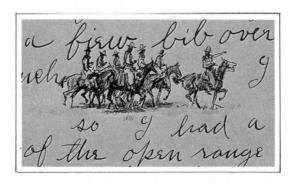

FRIEND GOODWIN, *October 23, 1907*

Among the artists Russell met on his early trips to New York was Philip R. Goodwin, an established illustrator by 1907 though only in his mid-twenties. Goodwin twice stayed with the Russells in Great Falls and at their cabin on Lake McDonald, in 1907 and 1910, and was of the opinion that it was "the treat of a lifetime" to spend a vacation in Charlie's company.

Many of Goodwin's commissions were for western hunting scenes, and his work profited from direct contact with Russell and the Montana high country. In turn, Goodwin's technical proficiency, acquired through study under Howard Pyle, benefited Charlie. Their friendship allowed Charlie to reveal a side of his character hidden from his rangeland cronies—that of the dedicated professional artist, involved in his craft, willing to discuss it and anxious to improve.

The model of the Kootenai canoe by Harry Stanford, a Kalispell taxidermist and an authority on regional lore, is on display with the rest of the "horse jewelry," costumes, and artifacts that made up the artist's studio collection in Great Falls. The three black-and-white paintings Charlie mentions completing indicate how busy he was in this period. Besides the two done for an article or book by Edgar Bronson, he had finished another for *Outing,* a New York magazine (for which Goodwin also illustrated) that featured several examples of Russell's work—prose as well as paintings—in 1907 and 1908.

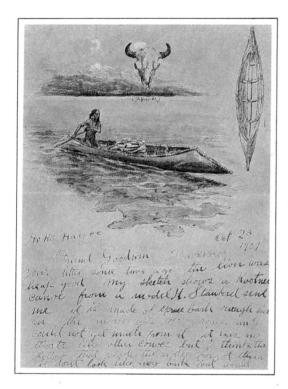

Ho Ho Hay-ee

Friend Goodwin I received your letter some
time ago the lion was heap good my sketch
shows a Kootnei canoe from a model H. Stanford
sent me it is made of spruce bark rough sid
in the modle was verry rough an I could not get
much from it it has no thorts like other conoes
but I think the fellow that made the modle forgot
them it dont look like any bark boat would
hang to gether with no brace to keep her from
spreding I wish you were here now the
wether is beautifull this sounds like a josh but
its on the square the sun hasent hid since you
left I fineshed my roping picture an
have done three black and whites two for
Bronson and one for Outing I went out to
the stock yards the other day to see a beef
heard from the upper sun river there was a
thousand head a pritty good heard for these
days the punchers baring a fiew bib overall
boys were a pritty good bunch I knew
most of the old timers so I had a good time
talking over days of the open range an Im telling
you there was some tolibel snakey ones rode
during our talk but as the old ones knew I don
most of my riding bad ones this way [sketch] I
dident have much to say an Im the same
way about letter writing so Il close the deal
with best wishes to all friends your friend
C M Russell

Xmas Where Women Are Few, *1907*

Women were scarce in Montana in the 1880s and 1890s and when a likely prospect did appear she was sure to be besieged by eager suitors. Charlie himself paid unsuccessful court to a rancher's daughter, Lolly Edgar. Whenever he rode up to visit, he found other cowboys ahead of him, and he could tell from their horses' brands who his rivals were.

Charlie's good friend Con Price once bid for the sympathetic attention of a girl by falling from his horse in view of her cabin. The fall was more realistic than Con intended, and he hit the ground with a thump. Rosser, his companion, then half-dragged Con to the cabin door. As Charlie told the story: "It's a cinch that anybody not on to the play would bet Con's got all his legs broke. . . .

"Con lays there, listenin' for footsteps of the ladies, but they don't come. There's no sign of life, an' the only livin' thing in sight is two hosses—Con's and Rosser's. They're driftin' mighty rapidly homeward. . . . Lookin' at these hosses, an' nobody comin' to the door, makes Con recover mighty fast, an' his groans turn to cussin'."

The aspiring thespians had staged their finest show before an empty house, and for their efforts were repaid with a ten-mile walk back to camp and ample opportunity to meditate on the woes of wooing in a land "where women were few."

Of all Charlie's old cowboy friends, Con Price remained closest. Con, five years Charlie's junior, got his first cowboy job in 1885 nightherding horses on the Belle Fourche Roundup in the Black Hills. Unlike Charlie, however, whom he met night-herding cattle on the Judith Basin Roundup about two years later, Con was a skilled rider and went on to become a top hand with several of the large Montana outfits. After marrying in 1899, he and his wife filed a squatter's claim in the Sweet Grass Hills and established what became the Lazy K Y.

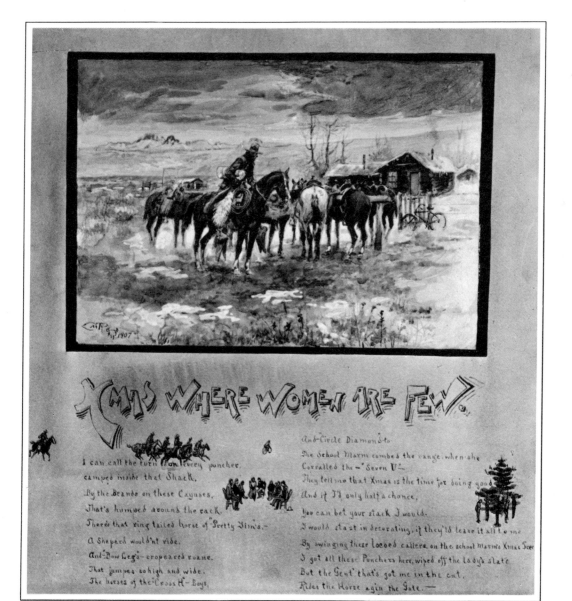

FRIEND GOODWIN, *ca. January, 1909*

Russell was fascinated by buffalo. Scores of paintings, drawings, and models of herds on the move, buffalo hunts and solitary bulls—as well as the omnipresent buffalo skull that formed a part of his signature—testify to his lifelong love affair with "nature's cattle." By 1908 the buffalo's glory days were long over, but for a while in October Charlie enjoyed the excitement of an attempted roundup of a herd owned by a mixed-blood Flathead named Michel Pablo. Pablo had acquired the herd's nucleus in the 1880s and watched it grow to some 700 head before the impending allotment of the Flathead Reservation forced him to put it up for sale. Much to Russell's disgust, the American Government dillydallied and Pablo eventually sold to the Canadian Government, in 1907 for $200 per head payable on delivery. That was the rub—delivering the buffalo. While most of the herd was shipped by the end of 1909, final delivery was not made until 1912. Over the years the buffalo had roamed the reservation at will, and were obviously a fair match for the cowboys employed to round them up. Thus Charlie Russell was an intent observer in October, 1908, and an actual participant in the roundup the following spring. His excitement is evident in this unusually long letter to Philip Goodwin.

one of
Peblos
riders

Friend Goodwin I guess you think its about
time I answered your last letter but you know
me if the moos you shot was like your sketch he
was a dandy I was out on a buffilo roundup in
October I wish youd been along it was on
the Flat Head reservation an open wild
country we saw lots of wild hosses never
getting closer than a mile an dont ever think they
wasent wild it seemeded like they allways
winded us before we sighted them they were
allways running our camp was on the Pandrall
[Pend Oreille] river surounded by a high roling
country I was camped with the Canadin
Officals who bought the buffilo 800 head owned
by a Half Breed Peblo by name knowing the
resivertion would be throne open he asked Unkle

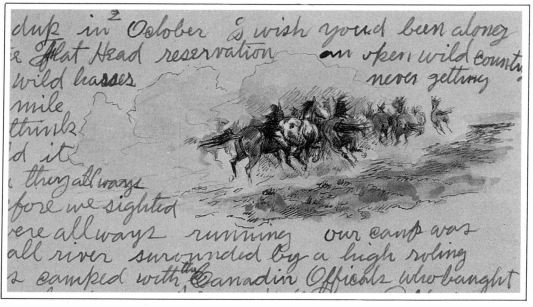

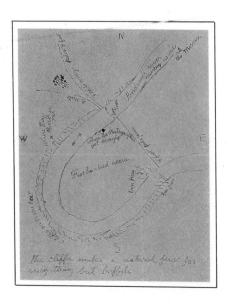

Sam to leave him a range but Unkle wanted it for
farmers then he asked him to by them an when
Unkel shook his head the Canadians jumped
in an grabed them at $250 a head since
the sale U S has made a buffilo pasture not 30
miles from Peblos range an our country has 4
head two of them presented by Conrad the other
two by some man at Salt Lake a large heard for
a country like ours if it had not been for this
animal the west woud have been the land of
starvation for over a hundred years he fed an
made beds for our frounteer an it shure looks
like we could feed an protect a fiew hundred of
them but it seemes there aint maney thinks lik
us I am sending you a rough map of the trak
that that was bilt to cach the Buffilo Peblos
riders wer all breeds an foolbloods making a
good looking bunch the first day they got
300 in the whings but they broke back an all
the riders on earth couldnt hold them
they onely got in with about 120 I wish you
could have seen them take the river they hit
the water on a ded run that river was
a tapyoker for them an they left her at the
same gate they tuck her catching a photographer
from Butt City on the bank we all thought
he was a goner but whin the dust cleared
he showed up shy a camra hat an most of
his pants lucky for him there was som seeders
on the bank an he wasent slow about using one
we all went to bed that night sadisfide with a 120
in the trap but woke up with one cow the
rest had climed the cliff an got away the
next day they onely got 6 an a snow storm struck
us an the roundup was called off till next
summer if you come out this sumer we will
go over an see it we can take the boat from
Kalispell an go down the lake its onely about
25 miles from the foot of Flat head lake to the trap
an we could get horses their an ride over I
come back by the lake to Kalispell it is a fine
trip Bob Benn sent his best whishes he sent
us some fine buffilo meet for Christmas were
are having a cold snap out here last night it was
38 below 0 an it has been snowing for for
days give my regards to Dunten an all who
know me whishing you and yours a happy
New Year your friend
C M Russell

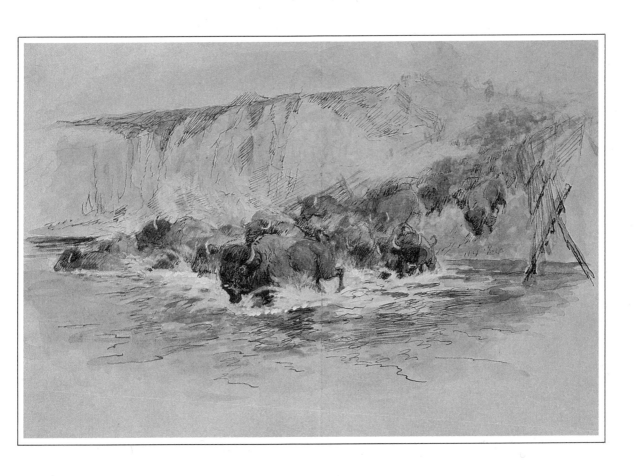

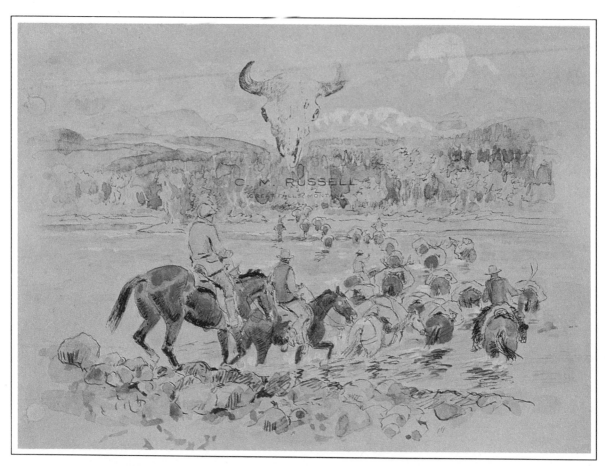

Have som boiled bef

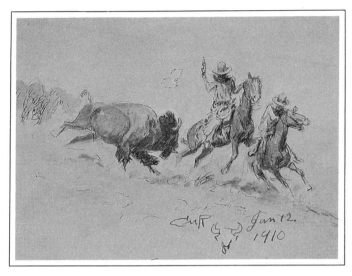

Random Sketches from Letters:
Opposite: Pack train crossing river
(top) from 1923 note to Judge
Bollinger. Self-caricature (bot. l)
from 1916 New Year's card. Guest
recoils from Charlie's camp cooking
(bot. r) —with good reason,
according to friends who'd sampled
it. Left: Quick shot saves Charlie
(r) from charging bull during buffalo
roundup.
Below l: "Moove" cowboy
stunting, from letter to Teddy Blue
in Charlie's last year, 1926. Below
r: Thanks to Montana
Congressman Charles N. Pray for
some books gives Russell another
opportunity to urge sympathy and
consideration for his lifelong friend,
the Red Man (1914).

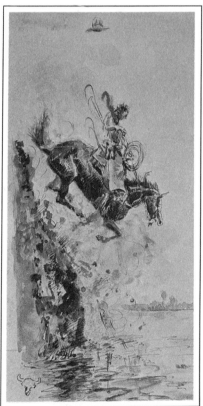

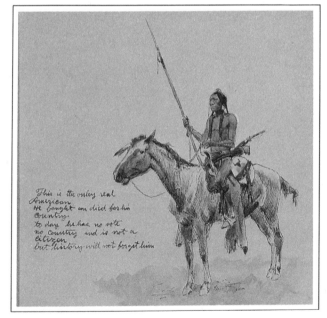

71

Note to Frank B. Linderman, *May 12, 1909*

The friendship between Charlie Russell and Frank Bird Linderman must have been foreordained. Both men were transplanted Midwesterners who left big cities at the age of sixteen—Russell St. Louis and Linderman Chicago—to seek a freer, more adventurous life in Montana. With marriage Linderman, like Russell, gave up his roaming ways and settled down. But both men remained fiercely devoted to the Montana of their youth. Both were inveterate outdoorsmen, students of native lore, and stout defenders of Indian rights.

In 1915, with the publication of *Indian Why Stories,* a collection of tribal tales illustrated by Charlie, Linderman was launched as a writer. Charlie, who found writing a chore, was of the opinion that "betwine the pen and the brush there is little difference but I believe the man that makes word pictures is the greater." When Linderman sent him a copy of a Cree alphabet, Charlie penned this elaborate thank you with the letters turned at random to resemble the Cree syllabary. A translation: "I have seen much travling talk of the yellow iron hunter an it is good he touches the little butons on his medison box [typewriter] that tells what his hart feels tis easy for the father of all has made him so but I the pictur man can talk only with my tongue

"The Great Father has maney children no two alike The big sage bird walks like the young brave but his flit is low an short his cousin the duck walks like a fat women of maney winters but is he lame on the water or in the clouds the buffalo has two hornes an 16 toes the white gote counts the same can the bull walk the snow ledges where stormes live

"My fingers count the same as yores but the sun has made our medison diffornt

The picture man has spoken"

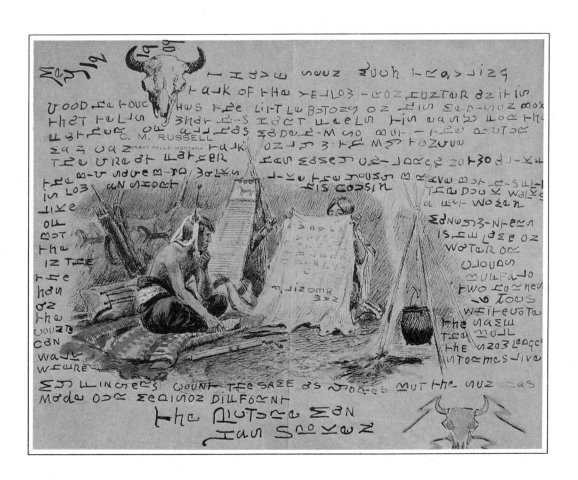

FRIEND ED, *1910*

Ed Botsford trailed a herd of beef north from Texas in 1888, and met Charlie Russell the next spring on the Bear Paw Roundup. The two batched together with other cronies in Chinook one winter, and when Russell took up painting full-time, Botsford joined Buffalo Bill's Wild West and began a thirty-seven-year career in show business. Whenever Charlie's visits to New York City coincided with those of the Wild West, he was sure to be on hand. In 1910, Russell watched Botsford perform at Madison Square Garden and returned the next day to present his old compadre with a portrait of two has-beens, himself and his horse Neenah. "I ride on canvis," he wrote, but a bit prematurely. According to one of the performers, Charlie got such a kick out of hobnobbing with the Wild West's cowboys that Buffalo Bill provided him with a silver-mounted saddle and a "beautiful dappled-white mount" so he could ride with them in the opening parade.

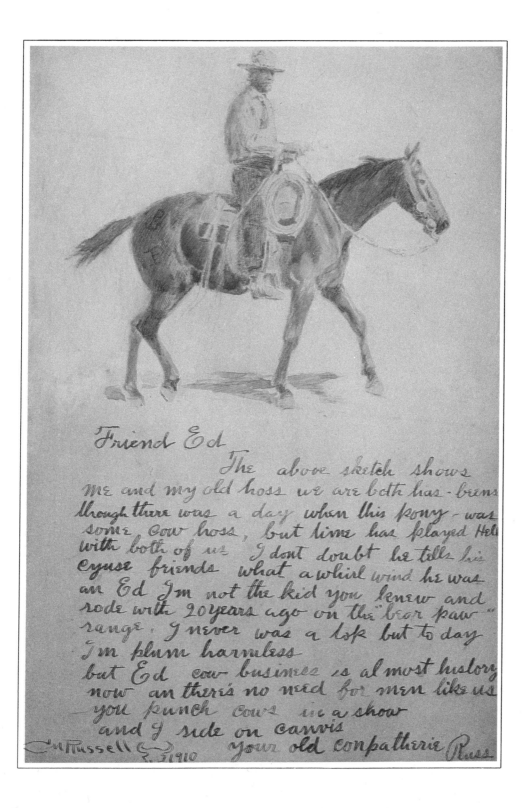

Friend Ed
 The above sketch shows
me and my old hoss we are both has-brens
though there was a day when this pony - was
some cow hoss, but time has played Hell
with both of us I dont doubt he tells his
cyuse friends what a whirl wind he was
an Ed Im not the kid you knew and
rode with 20 years ago on the "bear paw"
range. I never was a lok but to day
Im plum harmless
 but Ed cow business is al most history
 now an there's no need for men like us
 you punch cows in a show
 and I ride on canvis
 C M Russell your old conpatherie Russ
 2 5 1910

TO JIM GABRIL, *1910*

Jim Gabriel was one of those cowboys who hooked up with Buffalo Bill's Wild West in the 1890s, stayed with the show for several years, then drifted into a series of partnerships with other performers at a time when competition was stiff and profits shrinking as the movies began to cut into the audience for Wild West entertainment.

In 1910, when Russell wrote this verse tribute to his friend's riding skills, Jim Gabriel may have been associated with Col. Zack Mulhall's Wild West. He had earlier been involved in what was known as the "Jim Gabriel and L. M. Hunter Presenting Miss Blanche McKenney's Wild West/Indian Congress." When he pulled out, Miss McKenney denounced him as "very over-baring at all times if he dares to be." She did not intend her remark to be flattering, but perhaps it was his overbearing nature that made Gabriel the top bronc rider he was.

To Jim. Gabril
From his friend
C. M. Russell

1910

Hang an rattel Jimmy
Com back an get your gun
tha wether must be warme up there
your mighty near tha sun

That hoss is shure a wearing Jim
but your still on his hunk
if you had annother arme ar two
youd qurt him every jamp

No Jinny aint no frade strap man
he aint pulled leather yet
well he ride him, well I'd tell a man
its tha safest kind o bet
The playfull way hes cashed his head
shows plane hes after you
scratch him on tha sholder Jim
hes playing peek a boo

FRIEND PIKE, *December 7, 1910*

Henry Pike Webster and his father Frank W. Webster operated the Deer Creek Cattle Company near Coutts, Alberta, a few miles north of the Lazy K Y. Frank Webster was an old friend of Charlie's. The two met in Great Falls in the late 1880s, and Webster ran a grocery store there for several years before taking up ranching in Alberta. Consequently, all the Websters were invited to come down for a visit with the Russells. Charlie had seen Henry Webster recently during a visit to the Lazy K Y with Philip Goodwin, and proceeded to kid him about his riding. Webster might fancy himself a first-rate "bronk fighter" but in Charlie's "dream" he rode "loos and high": "Once ore twise I got a good view of the whole Sweet grass range Gold butte an all between you and the saddle."

Friend Pike I drempt of you a fiew nights ago it seems like I was up on the 7N ranch an we were out riding our convrsation drifted from one subject to another your grate ansesters that wore tails spiritualism all favorite subjects of yours finely falling to bronk riding I was sum supprised whin you started filling me up about what a bronk fighter you was you said there wasent nothing waring hair hoofs an hide from the Gulf of Mexico as fare north as grass grows that you couldent fork an qurit [quirt] every jump an spur from his jaws to the rute of the tail I thought you were joshing an said I came from a strip of country laying betwen the Mississippi rive an the home of Carry Nation where folks were ignorent with that you started to show me leaning over you th [?] ed the black at the same time hanging your spir in his sholder the black chashed [?] his head an the ball opened well Pike I seen som snakey horses rode but in this dream that black of yours made all the rest look like rocking horses he diped weaved an sunfished an when he quit you were in the middel of him. but I dident catch you quirting him aney you dident seem to have enough arms your riding was what Id call loos an high once ore twise I got a good view of the hole Sweet grass range Gold butte an all betwen you an the saddle Well Pike I wish you an your folkes would com down an make us a viset it would do you all good especaly your mother we got lots of bedding an grub an if you got to longing for the bunk hous you could bed down in the cabon tell your Mother if she will come Il cook slap jacks for her an Il try an get a windo for you to fix up an Il bake beenes for your Father with dirt in them you know how he loves them I got a letter from Goodwin an he sent som dandy photos I guess hel send you som he spoke of the good time he had up at the ranch well Hiney this is a long letter for me so I close hoping you are all well an best whishes to the family Your friend
C M Russell

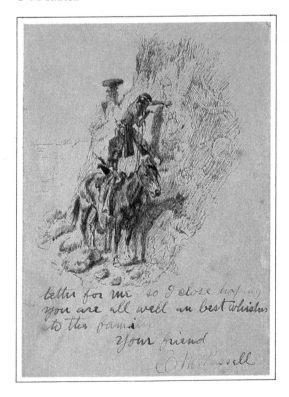

MY DEAR MR. KILMER, *April 24, 1911*

Charlie Russell habitually avoided self-promotion. To his way of thinking, his work spoke for itself. Tales abound about his indifference to making sales. One old-timer, who renewed his acquaintance with Charlie at an exhibition of his works in Calgary in 1912, observed that "he was never interested in selling them himself but always seemed to run them down. It was his wife who really sold them." But the letter to Kilmer proves that when the occasion demanded, Charlie was willing to do his bit to help Nancy "land" a prospective buyer—and his exhibition at the Folsom Galleries was such an occasion. At a point in his career when publicity still mattered, the New York *Times* ran a major feature on Russell a few weeks before the exhibition opened. It noted that among the paintings on display would be *The Medicine Man* (1908) "of which his wife and artist friends are exceedingly proud— Russell himself is proud of none of his works." The letter to Kilmer written a month later provides a direct rebuttal. Russell, too, recognized that his oil painting of a party of Blackfoot on the move was an exceptional creation, "one of the best pieces of my work." It is a judgment that stands to this day.

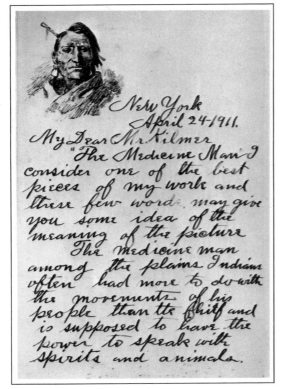

New York
April 24-1911.
My Dear Mr. Kilmer
"The Medicine Man' I
consider one of the best
pieces of my work and
these few words may give
you some idea of the
meaning of the picture
 The medicine man
among the plains Indians
often had more to do with
the movements of his
people than the chief and
is supposed to have the
power to speak with
spirits and animals.

My dear Mr. Kilmer
"The Medicine Man' I consider one of the best
pieces of my work and these few words may give
you some idea of the meaning of the picture

The medicine man among the plains Indians
often had more to do with the movements of his
people than, the Chief and is supposed to have
the power to speak with spirits and animals.

This painting represents a band of Blackfeet
Indians with their Medicine Man in the
foreground. The landscape was taken from a
sketch I made on Soan Tree creek in the Judith
Basin and I remember when this was a game
country. The mountain range in the background
is the Highwood with Haystack and
Steamboat Butts to the right

The Blackfeet once claimed all country from
the Saskatchewan south to the Yellowstone and
one of their favorite hunting grounds was the
Judith Basin. This country to day is fenced and
settled by ranch men and farmers with nothing
but a few deep worn trails where once walked
the buffalo but I am glad Mr. Kilmer I
knew it before natures enimy the white man
invaded and marred its beauty
Sincerely
C. M. Russell

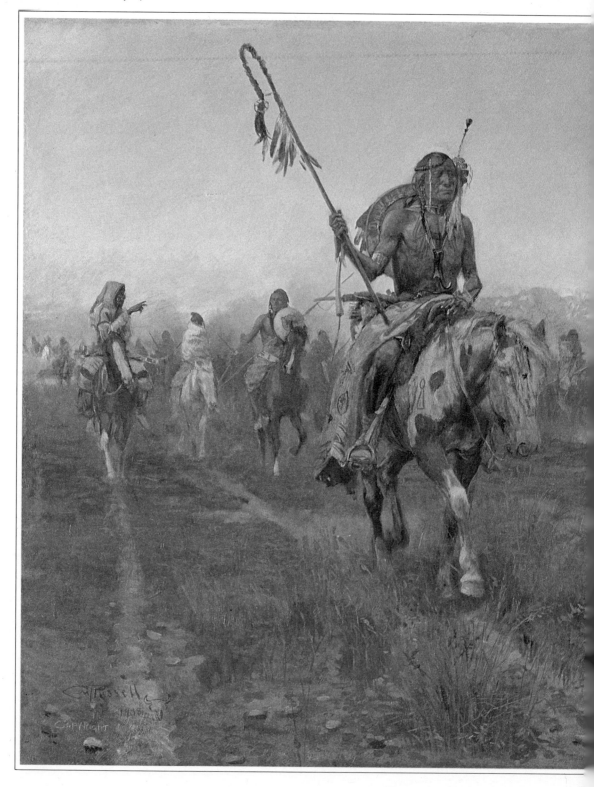

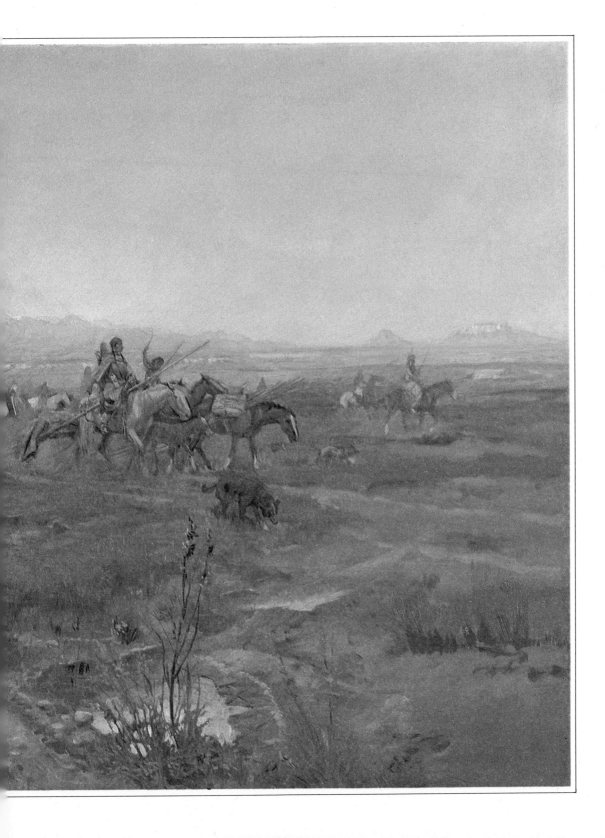

Here's how
old timer long lift and
a healthy one
May your Christmas
be full of pleasure
as These glasses are
full of fun
An heres to a happy
New year since 1864
Youve seen many a
New years Day may
You see as many
more

CM Russell 1901

HERE'S TO ALL OLD TIMERS, BOB, *June 5, 1911*

Robert Vaughn, a native of Wales, sailed to New York City in 1858
and wended his way west, farming and coal mining in Ohio and Illinois
before crossing hostile Indian country to the new-found Idaho gold
fields in 1864. By the time Vaughn's party reached Alder Gulch, the
Territory of Montana had been created. Consequently, Vaughn was a
part of Montana's story from when it was "but an infant in its cradle."
His experiences naturally impressed Charlie Russell, who, if he had any
regrets in life, regretted most that he had not seen the West fifty years
earlier. Vaughn arrived in Montana just a few months after Russell was
born, and lived through the pioneering epoch whose waning years so
entranced the Cowboy Artist. Eight Russell paintings illustrated
Vaughn's *Then and Now; or, Thirty-Six Years in the Rockies* (1900), a
collection of historical sketches and reminiscences about the early days,
and shortly after its publication Charlie inscribed a book to Vaughn
showing the old pioneer and his artist friend toasting one another.
Russell's poem "Here's to all old timers, Bob," with its watercolor
vignettes and meticulous calligraphy (no doubt the work of Friend
Trigg's schoolmarm daughter, Josephine), honored Vaughn on the
occasion of his seventy-fifth birthday, celebrated June 5, 1911.

Here's to all old timers, Bob,
 They weren't all square it's true,
Some cashed in with their boots on—
 Good old friends I knew.

Here's to the first ones here, Bob,
 Men who broke the trail
For the tenderfoot and booster
 Who come to the country by rail.

Here's to the man with the gold pan
 Whose heart wasn't hard to find.
It was big as the country he lived in,
 And good as the metal he mined.

Here's to the rustler that packed a notched gun
 And didn't call killin' sins,
If you'd count the cows and calves in his herd
 You'd swear all his bulls had twins.

Here's to the skinner with a jerk line
 Who could make a black snake talk,
An' could string his team up a mountain road
 That would bother a human to walk.

Here's to the crooked gambler
 Who dealt from a box that was brace,
Would pull from the bottom in stud hoss
 An' double cross friends in a race.

Here's to the driver that sat on the coach
 With six reins and the silk in his grip.
Who'd bet he could throw all the ribbons away
 An' herd his bronk team with his whip.

Here's to the holdup an' hoss thief
 That loved stage roads an' hosses too well,
Who asked the stranglers to hurry
 Or he'd be late to breakfast in Hell.

Here's to the 'whaker that swung a long lash
 An' his bulls bawled with fear when he spoke,
He'd swear on a hill he wouldn't drop trail
 If every bull starved in the yoke.

So here's to my old time friends, Bob,
 I drink to them one and all,
I've known the roughest of them, Bob,
 But none that I knew were small.
Here's to Hell with the booster,
 The land is no longer free,
The worst old timer I ever knew
 Looks dam good to me.

Sentiments
of your friend
C. M. Russell
1911

FRIEND EATON, *July 25, 1911*

Like most working cowboys, Russell always owned two horses—one to ride, the other to pack his possessions. He had lived a wandering life in the 1880s and early 1890s, and even as an established artist still liked to get away from the city and "play old times." Hunting trips and trail rides into the mountains remained a favorite recreation. Though Charlie was expert at "throwing the diamond" hitch on the pack animals, he delighted in recounting the misadventures of the parties he rode with. No one would appreciate his story about the leaking can of Eagle brand condensed milk more than Howard Eaton, the premier dude wrangler of his day. Russell and Eaton were old friends, and Russell often went along as a guest on Eaton's camping trips. In 1911, however, with a backlog of work following a successful one-man exhibition, "The West That Has Passed," at New York's Folsom Galleries, Charlie was unable to "brake away" from his easel.

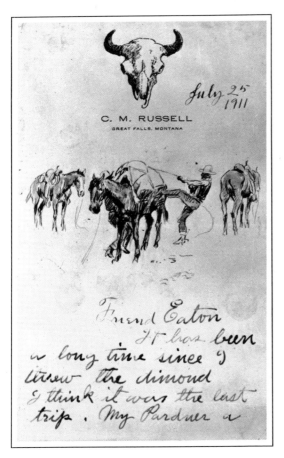

Friend Eaton
It has been a long time since I threw the
dimond I think it was the last trip. My Pardner
a farm raised man couldnt think of coffe
without milk so we blew for som caned cow
juice. It was the old kind you know the eagle
brand I belive an I think it came from that
bird its a sinch it never flowed from
aney animal with horns to make a long story
short it got loos on us. an I dont have to tell you
what happened when it started wandering
through our pack we had milk in every thing
but our coffe
* Eaton we would like mighty well to join you*
but Iv got so much work I cant brake
away thanking you for the invition with best
whishes from us both your friend
C M Russell

FRIEND GOODWIN, *January 26, 1912*

One important spin-off from Russell's well-publicized New York exhibition in 1911 was a formal commission from the state of Montana to execute a large historical mural. It was to grace the wall behind the Speaker's desk in the House of Representatives in the Capitol Building in Helena, and carried an award of $5,000, so Charlie found himself in competition with other, more experienced muralists for the contract. An appearance before the State Board of Examiners was the part of the process that Russell found most distasteful, since he was not one to toot his own horn. But with Frank Linderman and others lobbying on his behalf, Charlie was awarded the commission in July, 1911. The mural was to be about twelve by twenty-five feet—larger than the log-cabin studio could accommodate—so Charlie was literally forced to "lift the roof." Though he had never painted on such a scale before, his powers were fully developed by 1911 and the resulting work, *Lewis and Clark Meeting the Flathead Indians at Ross' Hole*, is commonly considered his masterpiece.

The "Rungious" and "Rongus" referred to in this letter was Carl Rungius, an accomplished painter of wild animals who traveled west each summer to renew his inspiration. Emerson Hough was a popular writer whose name was linked to Russell's as early as 1897, when Charlie provided six illustrations for Hough's *The Story of the Cowboy*.

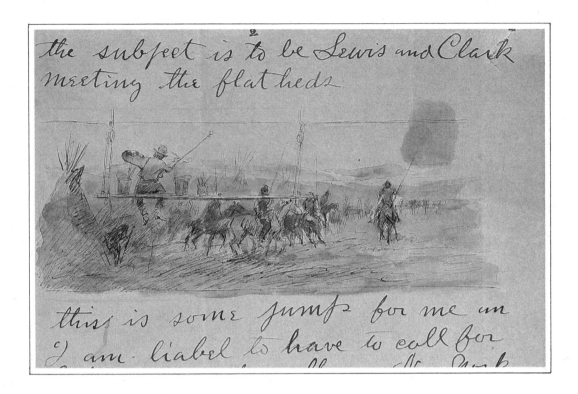

the subject is to be Lewis and Clark meeting the flat heds

this is some jump for me an I am liabel to have to call for

Friend Goodwin

I received your letter and was glad to here from you an Il bit you and Rungious had a good time I wold shure liked to have been with you we spent two months at the lake an had a pritty good time the deer are getting verry tame since shooting is bared several times the came right in front of the cabon I put salt in the trail an they came quite often to lick I got that job of the capital an as the picture is onely 25 feet long an 12 wide its got me thinking some the subject is to be Lewis and Clark meeting the flat heds this is some jump for me an I am liabel to have to call for help send for all my New York friends an put them to worke Pike Webster was down befor Christmas an stayed about two weeks an had a good time he often spoke of you I got an invitation not long ago from Emerson Hough an a friend of his that ownes some trading posts up north on the McKinsey [MacKenzie] river to go with them to the Arctic sea and I think I will go we start from Fort Edmonton June first an will be gon about three months

I saw Hendrcks of the Calinger Co an he said he had written to you we are out of that now. since poor Schatzlein died his death was a shock to all who knew him an I lost one of my best friends. he had trouble with his eyes but recoverd from that then was taken with appendicitis which caused his death I do not think we will be back this winter as I am going to be som busy with regards to yourself and folks the same to Rongus an all artist friends your friend
C M Russell

Lewis and Clark Meeting Flathead Indians at Ross' Hole, *oil, 1912*

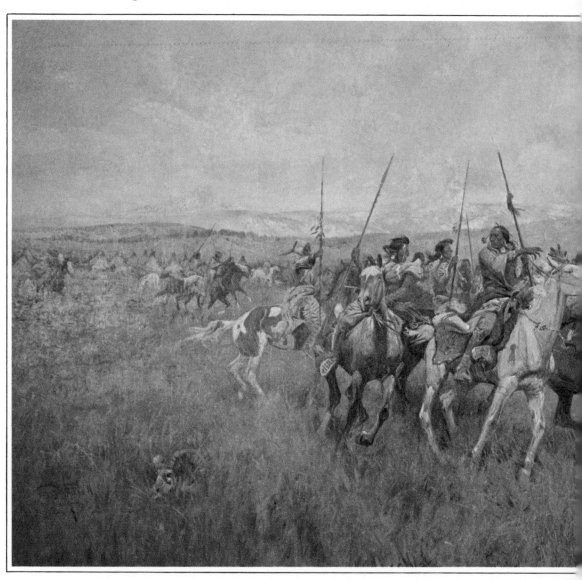

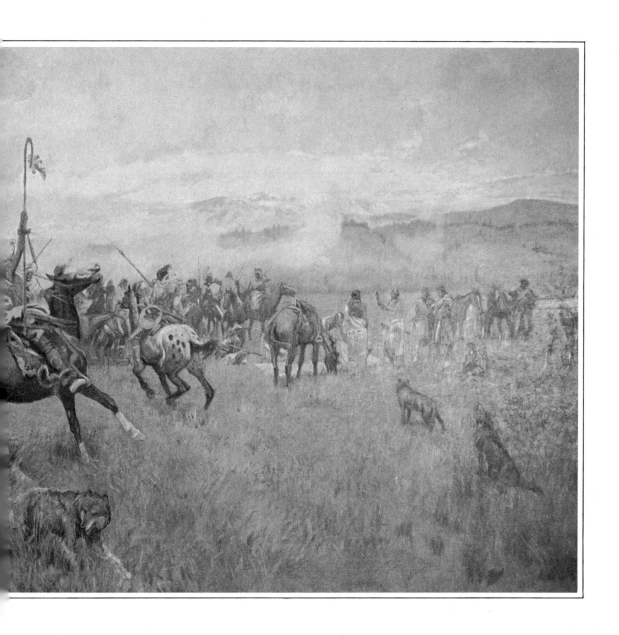

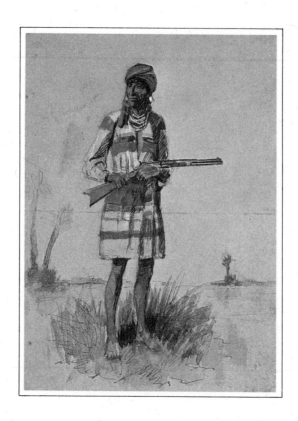

FRIEND SID, *April 7, 1912*

Enjoying their hard-earned prosperity, the Russells began to spend a part of each spring away from Montana in a warmer climate. When they were still visiting New York City regularly they tended to vacation in the South. In 1911, for example, after the Folsom exhibition, Nancy and Charlie took a steamer to Savannah. In 1912 and 1913 they holidayed in Florida. Charlie took in the sights and was impressed by all the strange "crawling swimming an flying things" he saw, though he told Bill Rance that an old drinking buddy of theirs "saw all these an more to an I dont think he was ever further south than Bannack this proves that you dont have to travel to see the wonders of the world." But, Charlie admitted to Sid Willis, you would see nothing in Montana resembling the Seminole Indians, unless a few of the local Scotsmen decided to put on their kilts for a brave display.

Stuart Florida
April 7
1912

Friend Sid this
Gentil man
is no kin to Sandy Erwin
or Bill Young tho from his
rigalia you d guess it
but its a safe bet he dont know
Bob Burnes an never herd the bagpipe
he s a Seminole Indian an lives
in the parts of Florida the whites
aint usin an theres quite a bunc
of that the whites are always kind
to these people an they let him have
all the lande thats under water
he could live better if his feet were webed
at tho he dresses like the scotch
they say hes rasyer to sivilize
with best whishy to the bunch
your frind C M Russell

93

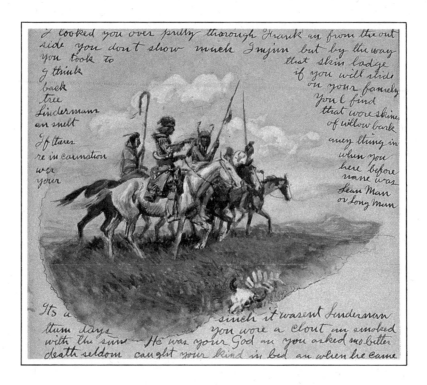

I looked you over pretty thorough Frank an from the out side you don't show much I injun but by the way you looks to I think that skin lodge back if you will slide tree on your family Lindermans you'l find an snelt that wore skins If there of willow bark re in carnation any thing in wer when you your here before name was Lean Man or Long Man

Its a since it wasent Linderman them days you wore a clout an smoked with the sun — He was your God an you asked no better death seldom caught your kind in bed an when he came

FRIEND FRANK, *September 14, 1912*

Frank Linderman recalled that nothing pleased Charlie Russell more than to be mistaken for an Indian. In turn, it was Charlie's supreme compliment, reserved for a special few who shared his own deep respect for the native Americans, to say that someone was all Indian under the skin. Linderman was both a sympathetic student of Montana's native tribes and an outspoken champion of justice for the red man. Charlie was active in the long campaign to secure a permanent reservation for Little Bear's Cree and Rocky Boy's Chippewa, but Linderman actually led the fight. "Jealous boomers who look forward to the complete settling of the West stand in the way of giving land to the Indians," Linderman told a Great Falls paper in 1913, and at his own expense journeyed to Washington to press the Indians' claim before the Secretary of the Interior. He did not back off in the face of local prejudice, personal attacks, or official indifference. Charlie, as much as the Indians he was aiding, admired Linderman's courage, and this letter is a tribute to a gallant warrior who, Charlie maintains, must have borne the name Lean Man or Long Man in some earlier existence.

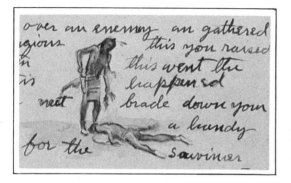

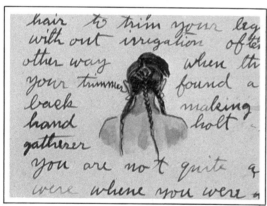

Friend Frank

I received your kind invitation as would shure like to go. all the more since I eat an smoked with you over a lodge fire I looked you over pritty thorough Frank an from the out side you dont show much Injun but by the way you took to that skin lodge I think if you will slide back on your famely tree youl find Lindermans that wore skines an smelt of willow bark If theres aney thing in reincarnation when you wer here before your name was Lean Man or Long Man Its a sinch it wasent Linderman them days you wore a clout an smoked with the sun He was your God an you asked no better death seldom caught your kind in bed an when he came it onely ment a better country with more buffalo you were not selfish your religion said all things lived again you were a heathen but your prayers were longer an more frequent than your Christian brothers In this life your words were fiew buffalo that romed your country in millions gave meat clothes and a good house baring a fiew roots an berries you were as carniverious as your brother the wolf who followed the heards like yourself from birds shells an the porcupine your women dressed your body in clothes sometimes you turned over an enemy an gathered hair to trim you leggions this you raised with out irrigation often this went the other way when this happened your trimmer found a neet brade down your back making a handy hand holt for the saivinier gatherer you are not quite as raw now Frank as you were whene you were on earth before but still show strong croppings of the savige an as I am your kind my self. Bill and I will meet you at Somers oct first With regards to you and yours Your friend

C M Russell

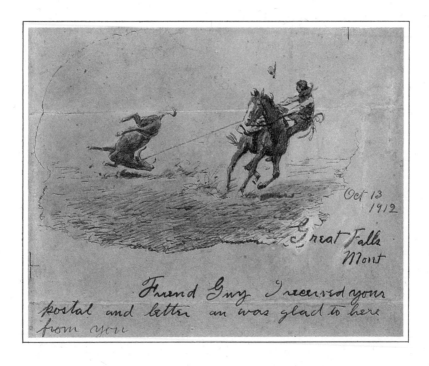

Oct 13 1912

Great Falls Mont

Friend Guy I received your postal and letter an was glad to here from you

FRIEND GUY, *October 13, 1912*

Charlie was in on the ground floor of what became a western institution, the Calgary Stampede. The driving force behind it was Guy Weadick, a former horse wrangler who had quit the range to ride the vaudeville circuit. He and his wife, "Florence (or Flores) la Due," made their living performing "Wild West stunts" such as fancy riding and trick roping, but Guy had a grander vision. He conceived the idea of a Calgary Stampede, but his dream went unrealized until 1912. Pageantry was part of the show—notably, a two-mile-long parade featuring original members of the North-West Mounted Police and a contingent of Indians who added "one mingled splash of glorious colour," according to the local paper. The rodeo, however, was the heart of the Stampede, and with a prize list set at an unprecedented $20,000, it attracted some of the best cowboy talent from Canada to Mexico. Hoopla and first-rate competition made for an unbeatable combination, as Charlie's enthusiastic thank-you letter to his host attests.

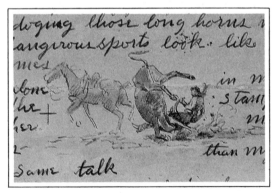

Friend Guy I received your postal and letter an
was glad to here from you You were so bussy
when I left I did not get to thank you for
the good time we had at the Stampede
I came west 31 years ago at that time baring
the Indians an a fiew scatered whits the
country belonged to God
but now the real estate man an nester have got
moste of it grass side down an most of the cows
that are left feed on shuger beet pulp but
thank God I was here first an in my time Iv seen
som roping an riding but never before have I seen
so much of it bunched as I did at Calgary Ive
seen som good wild west showes but I wouldent
call what you pulled off a show. it was the real
thing an a whole lot of it those horses judging
from the way they unloded them twisters wasent
broke for grandmas pheaton, they were shure
snakey an your cattel dident act like dary stock
to me I dont think aney I saw had been
handled by milk maids they were shure a
supprise to those old cow poneys that had been
running short horns all there life. It wasent hardly
fair to spring a gray hound waring
hornes an Guy football aint so gentel—the
bull ring an prise fighting is some rough but bull
doging those long horns makes all other
dangerous sports look like nursery games I
am not alone in my praise of the
stampede there are other men better judges
than myself make the same talk
with best whishes from my wife and I to you and
yours your friend
C M Russell

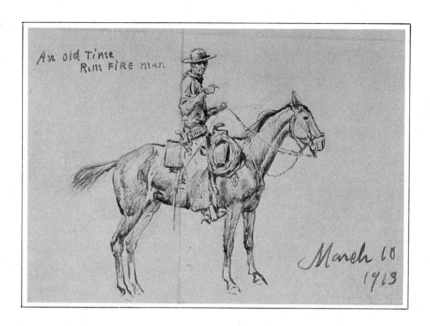

An old Time
RIM FIRE man

March 10
1913

FRIEND BOB, *March 10, 1913*

Though Charlie had greatly enjoyed the Calgary Stampede, he deemed it a pale imitation of the real thing and stubbornly stuck to his conviction that, talented as they were, the modern rodeo riders could not hold a candle to old-time bronc-busters like Bob Stuart. He was willing to admit that rodeo horses could undoubtedly outbuck the average cow pony, but the contest rider's equipment more than compensated for this disadvantage. "These modern twisters ride a swell-fork saddle with high horn," Charlie wrote. "The cantle is also high an' steep." In contrast, the old bronc fighter's saddle "was a straight-fork with a cantle that sloped back, an' compared to saddles now, the horn was low. I've seen bronc riders use an old macheer saddle with a Texas tree. It had two cinches an' was called a 'rim-fire' . . . The macheer, as it was called, was one piece of leather that fitted over the cantle an' horn, makin' a coverin' for the whole rig. This leather was smooth an' so slick it wasn't easy to stay in." All bronc twisters were glory riders, Charlie thought, but the "old time rim fire man" he never tired of drawing was his idea of a real cowboy.

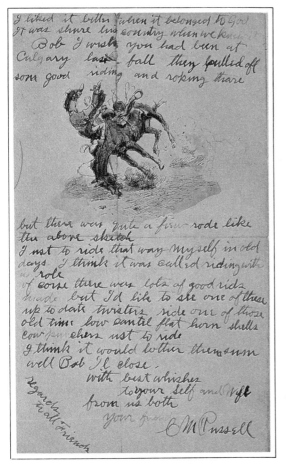

Friend Bob I guess you think its about time I
said something about that dandy pair of gloves
you sent to me but you know I appreciate them. I
spent New Years in Lewistown an met
some of our old friends time has hung
his mark on them the same as my self
Bob you woldent know the town or the country
eather its all grass side down now wher
once you rod circle an I night rangled a gopher
couldent graze now the boosters say its a better
country than it ever was. but it looks like hell to
me I liked it better when it belonged to God
It was shure his country when we knew it Bob
I wish you had been at Calgary last fall they
pulled off som good riding and roping thare but
there was quite a fiew rode like the above
sketch. I ust to ride that way myself in old
days I think it was called riding with a role
of course there was lots of good rids made but Id
lik to see one of these up to date twisters ride one
of those old time low cantel flat horn
shells cow punchers ust to ride I think
it would bother them sum well Bob Il close.
with best whishes to your self and wife from us
both your friend
C M Russell
regards to all Friends

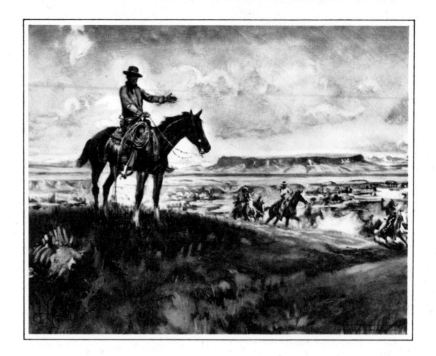

Charles M. Russell and His Friends, *oil, 1922*

Malcolm S. Mackay, a successful New York businessman, vacationed out west as a young man and so enjoyed the adventurous cowboy life that in 1901 he became part owner of a ranch south of Billings. Business kept him in the East, where he commuted to his Wall Street office from the family home at Tenafly, New Jersey, a pastoral setting that lured the Russells whenever they were in New York City.

One room of the Mackays' home was devoted to their Russell collection, generally thought to be the finest in private hands at the time of the artist's death. Its centerpiece, prominently displayed above the fireplace, was a large "poster" that Charlie painted in 1922 as a gift. It shows the artist with some old-time cowboys and Indians riding the range near Square Butte, a landmark between Great Falls and Cascade. Like his letter, this oil was a gentle reminder from Charlie to his eastern friend to always remember the West. Mackay did not forget. In 1925, he published a book of western reminiscences, *Cow Range and Hunting Trail,* and Charlie provided the illustrations. The Mackay collection forms the nucleus of the splendid Russell Gallery at the Montana Historical Society in Helena.

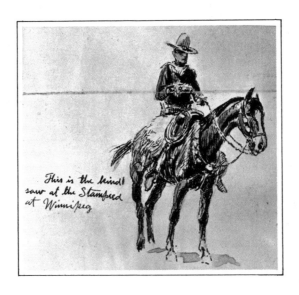

This is the kind I
saw at the Stampeed
at Winnipeg

FRIEND BILL, *ca. January, 1914*

In this letter to Bill McDonough, Russell again develops a comparison between the old-time bronc busters both of them knew and the rodeo riders Charlie had recently seen at the Winnipeg Stampede. And once again, while admiring the modern riders' skill, Charlie could not suppress the feeling that their swell-forked saddles provided them a deep and reasonably secure seat, giving them an advantage the working cowboy never enjoyed—and would have scorned.

The anecdotes about Pete Vann, a mutual acquaintance from the early days in the Judith Basin and along Milk River, were just a few of the many Charlie told about his old sidekick who, like McDonough, had remained in the cattle business despite all the changes that had taken place since the halcyon days of the 1880s.

Peet may not have been a finansier but we know he
was a cow man an when the big heerds left the
basin he baught a few mighty good cows Each of
these cows had four are five calves a year.
an Peet was mighty handy with the iron
this kind he was realy
 artistic
but I am glad old Peet
friends got thairs or aney of my
lander grabed everything before the dry

I still make Great Falls my home an have dun well
the last few years This is the kind we knew I spend my summers

Friend Bill I guess you think its about time I
said something. I received your letter last summer
and aint lying when I say I was gald to here
from you but Bill you know I always was slow an
time has made me no swifter Your and my
friends have scattered an baring Peete Van I
sendom see aney of the old boys we used to ride
with I see old Peet every little while hes
blacker an I think has ganed about three feet
where the flank cinch would come. he still runs
cows but dos most of his riding in an automobile.
he has an interest in a bank at the town of Guyser
Peet may not have been a financier but we know
he was a cow man an when the big heerds
left the basin he bought a few mighty good
cows Each of these cows had four and five
calves a year an Peet was mighty handy with
the iron this kind he was realy artistic but
I am glad old Peet or aney of my friends got thairs
before the dry lander grabed everything This is
the kind we knew I still make Great Falls my
home an have dun well the last few years with my
work. I spend my summers Lake McDonald
on the west side of the mane range where I have a
cabon. its about as wild a place as you can find
these day an that is what I like I went to the
Stampede at Winnipeg last Aug. an saw some
good riding and roping they had some mighty
snakey horses an lots of the riders were unloded. I
would shure like to see one of these up to date
swell fork riders git up in the middle of one with
an old time low horn an cantle I dont think
they would do as well as the old time busters we
knew som say the swell fork makes no
difference, but it looks mighty like what we used
to call a role an you know Bill men that used a
role were not considered bronk riders in the old
days I sill have my old Cheyenne saddle I left
Chinook on but both my old horses are dead years
ago I have one old horse left he like my self is
a has been but he dos for the little riding I do
Bill if you have a photograph of your self send me
one Id lik it best if you were mounted I am
sending one of mine with this letter I wish some
time you could come and see me we would
shure talk over old times we could go and make
old Peet a viset well Bill Il close for this time
with best wishes to you and yours your friend
C M Russell

"THE WEST THAT HAS PASSED."

Exhibition of Pictures by
CHARLES M. RUSSELL
(THE COWBOY ARTIST.)

& Friend

are invited to

The **Private View** *on Thursday,*
April 2nd, 1914. 10 to 6 o'clock.
(AFTERNOON TEA.)

The **DORÉ GALLERIES,**
35, New Bond Street, W.

Available any day until
Thursday, April 30th.

"The West That Has Passed": London, 1914

Charlie Russell's exhibition at The Doré Galleries in London in April, 1914, was the final link in a chain of events that demonstrates Nancy's shrewdness in managing her husband's career. It began in 1912 with the decision to attend the Calgary Stampede and hold an exhibition of Charlie's works there. It continued the next year with another exhibition at the Winnipeg Stampede. Both resulted in sales to Canadian buyers and commissions for works. Both established new contacts that Nancy was quick to cultivate.

Most important, the Calgary and Winnipeg exhibitions brought Russell's work to the attention of certain prominent English visitors, who then paved the way for the grand exhibition in London in 1914, "The West That Has Passed."

All told, Russell's London exhibition proved a worthwhile venture. At the time, it garnered considerable publicity for the Cowboy Artist and established him as a figure of international reputation.

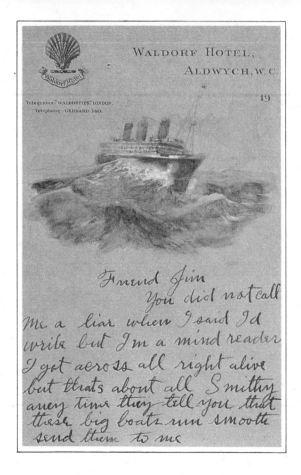

FRIEND JIM, *ca. March 30, 1914*

James P. Smith was co-owner of a contracting and fuel business in Great Falls. Naturally, he was familiar with the Great Falls Reduction Department of the Anaconda Copper Mining Company—known locally as "the smelter"—so Charlie set up his story about crossing the Atlantic by suggesting that the ship on which he and Nancy sailed was almost as big as the smelter. Its size did not guarantee a smooth passage, however. "Iv rode buck bords an stage coaches with drunken drivers an cyuses that made me pull leather," he informed Bill Rance, "but nothing as hard to stay in or on as this Ocean going hotel. Bill that room of ours used to weave and role some at times but it was never caused by water." Charlie always had a knack for associating an experience with the past he had shared with the person he was writing.

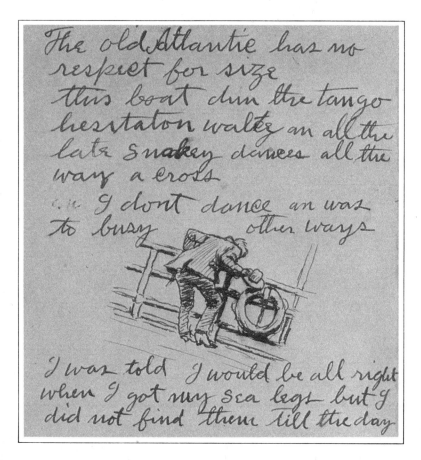

The old Atlantic has no
respect for size
this boat dun the tango
hesitaton waltz an all the
late snakey dances all the
way a cross
an I dont dance an was
to busy other ways

I was told I would be all right
when I got my sea legs but I
did not find them till the day

Friend Jim

You did not call me a liar when I said Id write but
Im a mind reader I got across all right alive but
thats about all Smithy aney time they tell
you that these big boats run smooth send them
to me the wave wagon I rode wasent
quite as big as the smelter but looked like it
an was about the size of the Rain Bow I wish
Bill Ward had been runing it I would have
shure put in a kick The old Atlantic has no
respect for size this boat dun the tango
hesitaton waltz an all the late snakey dances all
the way across I dont dance an was to busy
other ways I was told I would be all right
when I got my sea legs but I did not find them
till the day I landed an Iv been busy every
day since looking for my land ones they
say that sea sickness is good it cleans you
out thats no lie Il bet a vackum cleaner
couldent rais a thing from me Well Smith I
havent been here long enough to tell you aney
thing about this camp so Il close with regards to
you and the bunch your friend
C M Russell
If aney of my friends die or go to Jail let me
know Address Dore Gallerie
35 New Bond St London

HELO HIRUM, *March 30, 1914*

"Hirum" was Charlie's nickname for Kurious A. Hinote, who at one time ran The Maverick saloon in Great Falls with Cut Bank Brown. Since Charlie always tried to tailor his letters to his friends' interests, he devoted this one to a discussion of a London drinking emporium he had visited. Its woman bartender would have been out of place in a Great Falls saloon, he observed, but not its bouncer, who reminded him of an old-time prize fighter the bunch at home all knew.

I saw lots of sones but all
verry quiet the whispering kind
I wondered at all this quietness
till I noticed a well dressed gent
a fine looker from behind but when
he turned I was next he had a kind
gentel face like Ed Cuff its a sinch

this was the
hierd by the
to quiet the
This gentelman
man that noise
nervous
an I think by
clothes youd
noiseless articals
one look at this
krotecter an no
gentelman would
think; of insulting the littel lady
behind the mohogonay
well Hi I havent been here longenough
to see much but Il have something
to tell when I get back
with regards to You and the
bunch your friend
C M Russell

piece maker
owner of the dump
noisy ones
looked like it
would make
frisking his
find a fiew
like this.

Address DORE Gallery
35 New Bond St
LONDON

FRIEND SID, *April 20, 1914*

When he wasn't in New York hobnobbing with W. A. Clark and John D. Rockefeller, Charlie Russell was over in England calling on King George V. So, at least, he reported back to Sid Willis and the bunch at The Mint. Charlie's wanderings while his works were on exhibit in London took him to northern England and Paris for a few days. But he did not get to Ireland. Old tensions there still were rife as the struggle for home rule went on and on, and while Charlie felt he stood "all right with the Irish in Montana . . . in there native land they might peg me for a stool pigon."

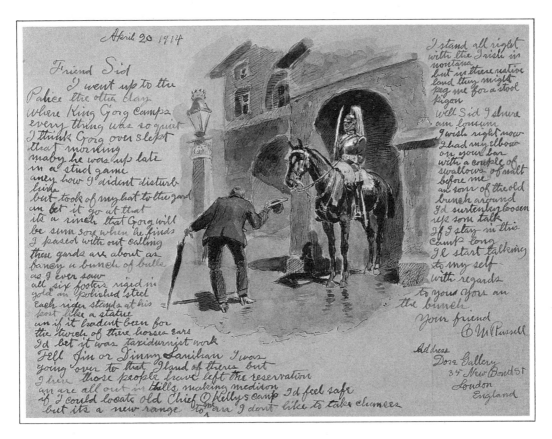

Friend Sid
I went up to the Palice the other day where King Gorg camps every thing was so quiet I think Gorg over slept that morning maby he was up late in a stud game aney how I dident disturb him but took of my hat to the gard an let it go at that its a sinch that Gorg will be sum sore when he finds I pased with out calling these gards are about as fancy a bunch of bulls as I ever saw all six footers riged in gold an polished steel each rider stands at his post like a statue an if it hadent been for the twich of there horses ears Id bet it was taxidurmist work Tell Jim or Dinny Lanihan I was going over to that Iland of theres but I here those people have left the reservation an are all out in Hills making medison if I could locate old Chief OKellys camp Id feel safe but its a new range to me an I dont like to take chances I stand all right with the Irish in Montana but in there native land they might peg me for a stool pigon well Sid I shure am lonsum I wish right now I had my elbow on your bar with a couple of swallows of malt before me an som of the old bunch around Id surtenley loosen up som talk If I stay in this camp long Il start talking to my self with regards to you yors an the bunch
your friend
C M Russell
Address Dore Gallery 35 New Bond St London England

109

FRIEND FRANK, *April 25, 1914*

Charlie was oppressed by the weight of the past in England. There you literally walked on the bones of those who went before, "an judging from the richniss of the vedgatation our for fathers made good futerliser." To a man like Frank Linderman, who cherished raw wilderness as much as Charlie, England had little to offer. Both men subscribed to the sentiments Linderman expressed when he dedicated his first book to those "who have known and loved old Montana."

England, in contrast to Montana, was crowded with "enough soil enricher walking around . . . to last till this old world takes the count." But Charlie granted the island its beauty, and praised its people for working hard "to save a fiew things God made."

The reference to Wallace Coburn, Montana's "Cowboy Poet," is explained more fully in Charlie's letter to him of January 27, 1915.

Friend Frank
I got both of your letters an was shure glad to here
from you. This is an old old land with more
people under the sod than there is on top. an
judging from the richniss of the vedgatation our
for fathers made good futerliser an no doubt this
will allways be a good land for the sod buster as
there is enough soil enricher walking around right
now to last till this old world takes the count. I
was out to the Towar of London the other day
this shack was laid up in 1078 by Bill the
Conqueror Bill like your self was sum hunter
an cleaned up about 30 squar miles of nesters to
make a game range At the Towar I saw
maney suits of clothes made by the black smith an
worne by Kings who mosty died in the shell An
from what I here would be clased with Slade
Phiner an that bunch I was out in Hide Park
yesterday an saw lots of equesterins for fear
your ignorance wont let you Savy riders or men
on horse back While viewing this bunch I

couldent help but think if those dead antiques
would rais from their moss grone beds In plow
shere clothes an looking like switch engin what
a tapioca it would be for them to lope out in the
park an harpoon these 1914 tailor made
humans of corse It could not be called sport but
like lawn tennice a quiet lady like game or out
door pass time Say Frank when you see
Wallice ask him if he thinks just because I cut the
edge of his range with a fiew verses it give him
a right to grase mine off with pictures Well
Frank this is a man handled land mad land but
Il say this much for the English they have
worked hard to save a fiew things God
made I have seen lots of deer phesant patriges
an rabbites. The English ar a slow but nature
loving people who have kept there small
country beautiful an Il tell you all about it
when I get home with best Whishes to you an
yours Your friend
C M Russell

Tell'um you heap good Christmas

Charlie at Christmas: "Entirely a matter of giving."

Charlie Russell was no churchgoer, though he numbered churchmen among his friends. His religious views were broadly tolerant, and he had as much respect for the Indian who found God in nature and worshiped the sun as he had for the Jews and Christians he knew. But he loved Christmastime, and the holiday season never failed to bring out the boy in the man. As Christmas neared, the log-cabin studio became Santa's workshop, and Charlie Santa's busiest elf as he produced pen-and-ink sketches, original wax models, hand-painted plaster castings, and watercolors and oils for a select few friends, and illustrated greeting cards, often with a verse conveying the Russells' good wishes, for their many acquaintances. Occasionally Charlie went beyond his jolly Santas, his merry cowboys toasting the season, and his beaming cartoon Indians to express a reverent respect for the meaning of Christmas. When his hunting and fishing companion Judge Bollinger professed to believe in nothing more in life than "a good cook," Charlie presented him with a watercolor of *The Three Wise Men* (gouache, 1920) approaching Bethlehem. Its silent statement was Charlie's strongest rebuttal—and a rare departure from his usual themes.

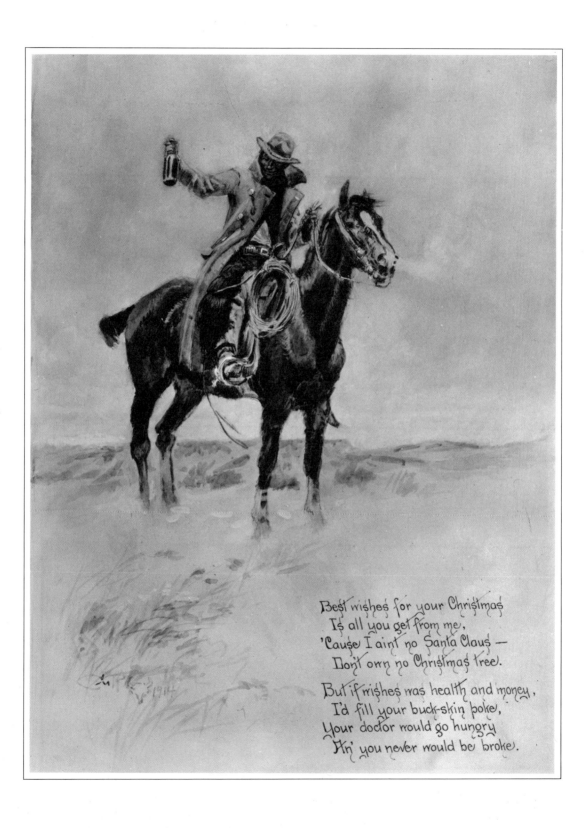

Best wishes for your Christmas
Is all you get from me,
'Cause I aint no Santa Claus —
Don't own no Christmas tree.

But if wishes was health and money,
I'd fill your buck-skin poke,
Your doctor would go hungry
An' you never would be broke.

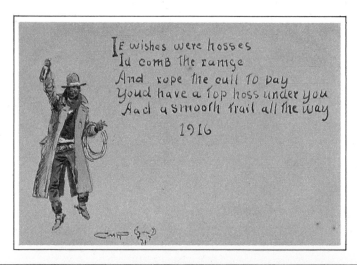

If wishes were hosses
Iu comB the range
And rope the cull To Day
Youd have a Top hoss under you
Aad a smooth Trail all the way

1916

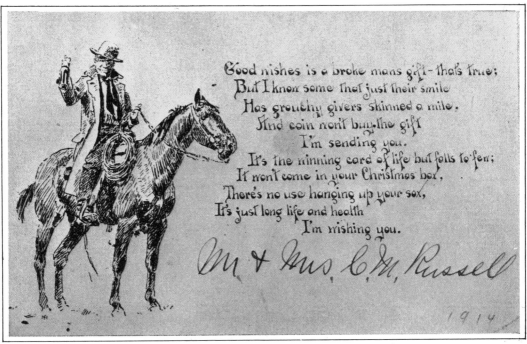

Good wishes is a broke mans gift – thats true;
But I know some that just their smile
Has grouchy givers skinned a mile.
And coin wont buy the gift
I'm sending you.
It's the winning card of life but falls to few;
It wont come in your Christmas box,
There's no use hanging up your sox,
It's just long life and health
I'm wishing you.

M. & Mrs. C. M. Russell

1914

FRIEND WALLACE, *January 27, 1915*

Charlie was a movie addict and he particularly liked to "play off a little corn" at westerns. He knew they were silly, of course, and packed more gunfire into twenty minutes than the Judith Basin did into twenty years. But they showed real horses at full gallop and they sometimes featured old-time cowboys, so he was hooked. Among the men he knew who got into the movie business was Wallace Coburn, son of a prominent Montana cattleman. Wallace and Charlie rode the range for Robert Coburn's Circle C outfit in the early 1890s, and together produced a little book in 1899, *Rhymes from a Round-up Camp.* Wallace supplied the verse and Charlie the sketches. But there was more money to be made in painting than rhyming, and by the time his father sold the Circle C in 1916 Wallace was already into movies. He organized a company to film an adaptation of one of his poems, "Yellowstone Pete's Only Daughter." He was to star, and the picture was to be shot in Montana. This was probably the venture Charlie meant when he wrote, "well old boy I here that . . . you now handel another kind of riders like the gent above that aney one can see for a dime."

This species is almost extinct but he once ranged from the timber rims in the east to shores of the Pacific from mexico north to snow bound land He knew horses an could tell you what a cow said to her calf the floor of his home was the prarie the sky his roof which often leaked his gift of God was health and he generly cashed in with his boots on he was only part human but I always liked animals

Friend Wallace

some time ago I received a note from your Wife asking for a sketch of a buffalo for your letter head I would do it but am under contract with the Osbornes and can do nothing in the way of advertising
well old boy I here that since the Granger has turned the country grass down leaving nothing for the cows that you now handel another kind of riders like the gent above that aney one can see for a dime an as there is now more real thing I my self play off quite a little coin at them screen round ups we both knew this kind. Wallace he was some times pritty scary but never with out caus. it was some times braught on by cow swallows of new home made booze this often caused him to pull his barker an as his catriges were never blanks there was some mighty real looking acts pulled off and I dont doubt that they would have made a mighty good movie but I wouldent want to turn the crank that took the real its a sinch the smoke would have blured the picture I never got to thank you for those lif like sketches you sent me in London but if you want to hold my friendship dont do no more my range is over stocked now an I dont want every old cow hand grazing it with best whishes to you and yours your friend
C M Russell

This rider dident quite win

Jan 28, 1916

Friend Guy, I received your
letters, an am a little slow about
coming back with paper talk. But here goes
I am glad to here you are going to pull
another Contest for the folks
Those prizes your hanging up shure
look good, But judging from horses and steers you
delt out at Calgary and Winnipeg
the rider or roper that takes a prize
shure had something coming
I have lived among riders most of my
life and late years Iv been taking in
Contests at differnt places but yours has
got them all skined to the dew claws
An Il take my hat off to eney rider who
takes or tryes to drag a prize from you
An Injun once told me that bravery came
from the hart not the head. If my red
brother is right Bronk riders and bull

dogers are all heart above the waistband but its a good bet theirs nothing under their hat but hair

well Guy I hope you git a cross all right and show them Cliff dwelers the real thing
they have all seen wild west shows but yours is no show its a contest where horses and riders are strangers
its easy when a bronk twister knows every jump in a hoss but hes gambling when he steps across one he never saw before you Savy
well Guy I close with best regards to your self and Wife your friend
C M Russell

give my regards to Borine and all friends
we will be in New York about the first of March then if you are still in the big camp we talk it over
is Ed Borine still in that owels nest on 42

FRIEND GUY, *January 28, 1916*

Guy Weadick was a conscientious promoter, and it was his proud boast that the Stampedes at Calgary and Winnipeg paid out every penny of the prize money promised contestants. But Weadick's extravaganza at the Sheepshead Bay Speedway in New York, held August 5–12, 1916, proved a financial bust. Despite the exciting posters designed by Ed Borein, the crowds were sparse, revenues failed to meet expenses, and Weadick was unable to fulfill his commitments to the contestants. As a participant summed up, "everyone took a beating on it." Charlie Russell would have been sorry but not surprised that "them Cliff dwelers" were still not ready for "the real thing"—an honest-to-God rodeo and not another Wild West show.

HELL O BUCK, *January 29, 1916*

Charlie made common cause with "aney body that knows and loves the old west," and one of his allies was George W. "Buck" Connors, a featured performer with Buffalo Bill's Wild West. Pawnee Bill (Gordon W. Lillie), whose own show combined with Cody's in 1909 to become Buffalo Bill's Wild West and Pawnee Bill's Great Far East, inherited Connors as his private secretary, and described him as a "famous rifle shot expert, mustang and bronco tamer, cowboy and rough rider," as well as a former "government scout under Buffalo Bill." Given due allowance for show business exaggeration, Buck Connors was real enough for Russell to recognize as a friend and to join in lamenting —in the surviving page of this letter—the passing of the old West they both knew.

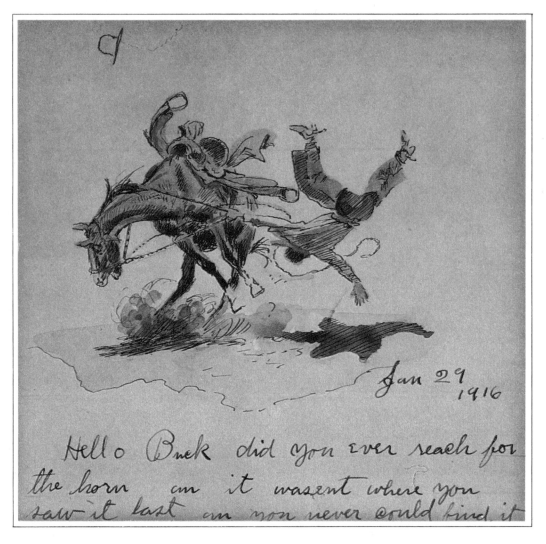

Hell o Buck did you ever reach for the horn an it wasent where you saw it last an you never could find it that what the Gent above is looking for Maby you think Im getting familiar calling you Buck an I never saw you but once and then your in the middle of a snake a way back in that big camp of Cliff dwelers But these days aney body that knows and loves the old west seems like a friend of mine. An I dont like to call them Mr or Sir

in your litter of Jan 12 your complaning about the way the old west is slipping away I dont know your country but I dont think its as bad as this It will be 36 years ago this March I came here then baring a fiew whits

Friend Frigg we
in Chicago which means in

FRIEND TRIGG, *February 24, 1916*

1916 brought an exhibition of Russell's pictures at the Thurber Galleries and another less-than-flattering letter to Albert Trigg about "the light smoke and smell" of Chicago. Charlie, like many other Montana cowboys, had accompanied shipments of cattle to the city's stockyards and stayed around long enough to blow his wad and beat a hasty retreat home to "the big out doores." One of Charlie's Rawhide Rawlins stories recounts the experiences of a young cowboy who came into some money and headed to Chicago back in 1883: "The minute I hit the burg, I shed my cow garments an' get into white man's harness. A hard hat, boiled shirt, laced shoes—all the gearin' known to civilized man. When I put on all this rig, I sure look human; that is, I think so. But them shorthorns know me, an' by the way they trim that roll, it looks like somebody's pinned a card on my back with the word 'EASY' in big letters. I ain't been there a week till my roll don't need no string around it, an' I start thinkin' about home."

The moral of the story hardly needs elaboration. Chicago never was a place for cowboys—and it was still no place for cowboy artists.

Friend Trigg we are still in camp back of the stock yards its about thirty two years since I first saw this burg. But I remember that morning well. I was armed with a punch pole a stock car under me loded with grass eaters I came from the big out doores and the light smoke and smell made me lonsum. The hole world has changed since then but I have not Im no more at home in a big city than I was then an Im still lonsum If I had a winter home in Hell and a summer home in Chicago I think Id spend my summers at my winter home there might be more people there but there couldent be more smoke But there is lots of good people here maby it aint there fault I suppose Great Falls will be lik Cicago some day but I wont be there well Trigg I here the snow is all gon an I know youl miss it but youl have to bear it You might arrange to join som poler expodation With best Whishes to your self Mrs Trigg Miss Josephine the chickons gold fish and bird this gose for both of us your friend C M Russell

THE FIGHTING CHEYENNES

The Red man was the true American
They have almost gon. but will never
be forgotten
The history of how they faught for
their country is written in blood
a stain that time cannot grinde
out
their God was the sun their Church
all out doors their only book
was nature and they knew all
its pages
 C M Russell

Book Inscriptions

Russell was frequently called upon to pen inscriptions in western books. Of the two reproduced here, the first was probably done for Joe Scheuerle, a painter of Indian portraits, while the Russells were visiting in Chicago in February, 1916. Its sentiments about the red man were vintage Russell, and particularly apt in a copy of George Bird Grinnell's *The Fighting Cheyennes* (1915). Grinnell accompanied Custer's expedition into the Black Hills in 1874 and knew the Northern Plains in the buffalo days. He played a leading role in the establishment of Glacier National Park and was one of the celebrated Indian authorities of his time.

The second inscription was done for a neighbor's boy, Neddy Bay Lincoln, in a copy of Frank Linderman's *Indian Why Stories* dedicated, coincidentally, to "CHARLES M. RUSSELL, The Cowboy Artist / GEORGE BIRD GRINNELL, The Indian's Friend."

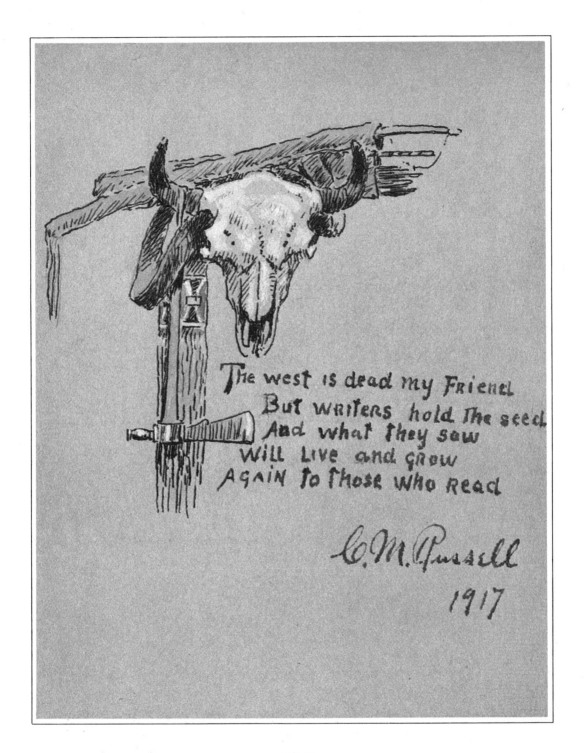

The west is dead my Friend
But writers hold the seed
And what they saw
Will live and grow
Again to those who read

C. M. Russell
1917

SAY SID, *March 21, 1916*

During Russell's first visit to New York, in January 1904, the New York *Press* recorded his reactions. "He has lived nearly all his life near the majestic Rockies," the feature writer commented, "so to him the tallest skyscrapers are but modest piles of stone in comparison. He loves the West and its rugged people, and it is hard for him to accustom himself to ways of the folk who live near the Great White Way. . . . Taciturn as a Sioux chief, self-contained and impassive, he is hardly the man to care for pink teas. He will remain a Westerner of the old school to the end."

Time proved the reporter a prophet. In New York in 1916 for another exhibition at the Folsom Galleries, Charlie was still unimpressed by the skyscrapers—all they did was block out the sun. New York's weather was about on par with that of Neihart, a mining town in the Little Belt Mountains on the western edge of the Judith Basin famous for its saloons, sporting life, and frigid waters. As for amusement, Charlie was still visiting New York's zoos to get back in touch with nature's creatures. His grumbling, of course, was all grist for Sid Willis's convivial Mint.

March 2! 1916

Say Sid
 dont let
nobody tell you this
is a good place to
winter
 for snow this camp
would make Neihart
look like Palm beach
 an if it wasent for shovel
 men Little Bears folks
could come back here an git all
kinds of coin building snow shoes
for these Cliff dwelers
of corse the thermometer dont fall
down like it dos out in Gods coun
try
but its a safe bet thes breeses
aint no relation to a chinook
I can tell the sun shines here by
the light on the sky serapers
but I have onley seen the sun
once and then I was looking
strenght up
the onely one I seen from our
home was a Silver tip in
Sentral Park and he looked
home sick
Sid theres a few people in montana
I dont care for but when I git
back here theres nobody out
home I dont like so give my
regards to everybody
 and your self
 your friend
 C M Russell

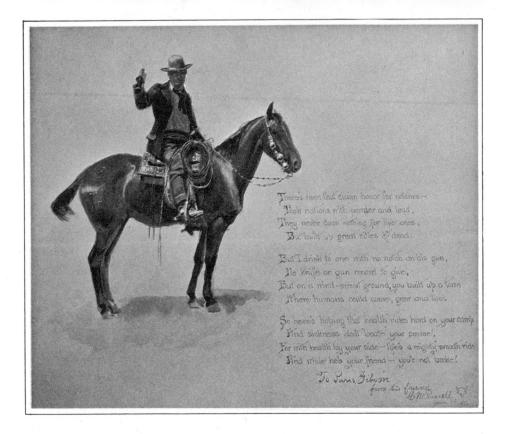

There's men that claim honor for notches—
Took nations with powder and lead.
They never does nothing for live ones,
But built up great cities of dead.

But I drink to one with no notch on his gun,
No knife or gun record to give,
But on a mind-swept ground, you built up a town
Where humans could come, grin and live.

So here's hoping that health rides herd on your camp
And sickness don't locate your smoke,
For with health by your side—life's a mighty smooth ride
And while he's your friend—you're not broke!

To Paris Gibson
from his friend
C M Russell

TO PARIS GIBSON, *June 30, 1916*

Paris Gibson was Great Falls' grand old man, and though his vision was forward-looking and progressive and Russell's was backward-looking and nostalgic, Charlie was quick to sing his praises. Born in Maine in 1830, Gibson made his way west in 1879. Traveling upriver to the great falls of the Missouri, Gibson saw a potential for development. The falls would power industry, while the plain to the south offered a perfect setting for a city. On the spot, Gibson decided to found Great Falls. In 1883, in partnership with the railroad magnate James J. Hill, he surveyed and platted the city, and when it was formally incorporated five years later he became its first mayor.

A public-spirited man, Gibson served in the Montana Senate in the 1890s and in the United States Senate from 1901 to 1905.

This illustrated poem paid fitting tribute to Paris Gibson on his eighty-sixth birthday.

HELL O SANTA FE, *March 24, 1917*

In October, 1916, Charlie and Nancy made a memorable excursion through Navajo country and along the Grand Canyon as guests of Howard Eaton. It was their second trip into the desert and both were enthralled with Arizona. Eleven years later, as a widow, Nancy partially retraced their route. "This has been a trip of memories," she told a friend. "Chas. just loved it all and had such a good time every day then around the camp fires at night they always had the big talk." Among those Charlie came to know and like on the trail was Tom Conway, a tourist agent for the Santa Fe Railroad. In thanking him for the good time, Charlie addressed him affectionately as "Santa Fe."

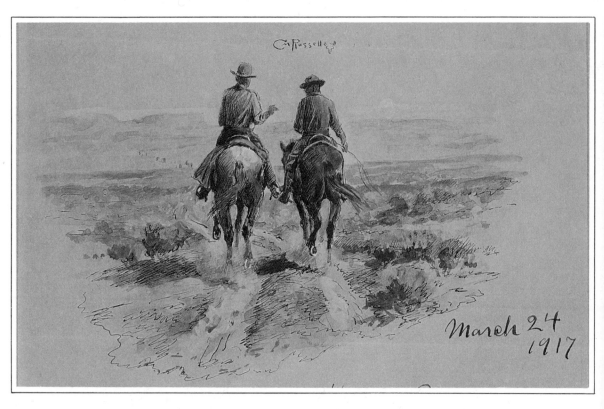

March 24 1917

Hell O Santa Fe

Well Tom, I guess its about time I said thank you
for the good time we had at the Canyon
Because I have not written dose not mean that I
have forgotten you
as a single handed talker Im better than a green
hand. but Im mighty harmless with a pen If I
was close to you Ide tell you all about it but with
this long range talk my sights are warped and I
shoot under ore over every time · but Tom I
wont forget you ore Arizona soon In the city
men shake hands and call each other friends
but its the lonsome places that ties their harts

together and harts do not forget Those days
that you joined me on the rear gard we talked and
listened turn about an I gethered from the talk
you spilt tho our trails were far apart we had
travled the same gate and our trackes pointed the
same way it was not always the trail of good
people but the one traveled by regular men
Tom just before Christmas we received a verry
nice pholio for photos it came from your
camp. and we think maby you sent it if
it was you say so and I will thank you with
best whishes from us both your friend
C M Russell

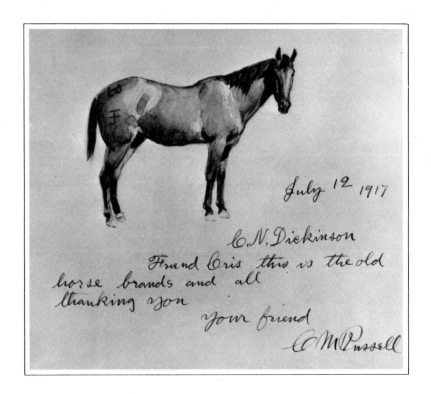

July 12 1917

C. N. Dickinson
Frand Cris this is the old
horse brands and all
thanking you
your friend
C M Russell

FRIEND CRIS, *July 12, 1917*

Charlie was crazy about horses. As a boy he raced his pony around the family estate, and in the last year of his life he furiously protested the movement to exterminate the wild horses that still ran loose on Montana's range. "If they killed men off as soon as they were useless Montana wouldent be so crowded," he wrote. To Charlie, horses were individuals. He executed loving models of three of his own mounts— Grey Eagle, Red Bird, and Neenah—and wrote a tribute to his first and favorite horse, Monte or Paint. "She can't talk," he once remarked, "but we understand each other."

In 1917 Charlie was casting about for a handy place to pasture Neenah. He asked Chris Dickinson, a Great Falls neighbor and founder of what became the Great Falls Meat Company, if he could put Neenah out on a field where the company grazed livestock on the short, nutritious buffalo grass. Chris asked Charlie to give him a note describing the horse's brand and color so that Neenah would not be confused with the other stock. This letter was Charlie's reply.

FRIEND JIM, *August 25, 1917*

When the Russells retired for the summer to Bull Head Lodge, Charlie found himself cut off from his Great Falls cronies. Nancy did not choose to mix with them, and few were ever invited to the lake as guests. Since the dislike was mutual, they accepted the situation and kept in touch with Charlie by sending him items he could not readily procure at the lake—cigars, liquor for the pleasure of others, fresh corn, and even a box of cantaloupes topped off with a watermelon. Jim W. Perkins, a linotype operator for a Great Falls daily, doubtless shared this nostalgic thank-you letter with "the home gard" at one of the downtown cigar stores where Charlie bought his Bull Durham and shot the breeze on his afternoon rounds.

Aug 2ᵈ 1917

Friend Jim
 I got a box of cantilope
all so a big water melon there was no name with them
but I'm a good guesser
Jim among moovies your not always a good picker
But in a melion patch your a Judg and a Gentilman
I'v been told that to read the good things in a melon
through its hide must be learned in boyhoods happy
hours if this is true judging from the quality of frute
you sent us its a saf bet you got bird shot in your
hide right now
As well as I know you Purk if I owned a patch of this
water frute and I saw you in the nabor hood right thens
when I'd start night hearding my melons and I'd
hang a bell on the big ones
 give my regards to the home gard
 for yourself at the sugar store hold som out
 with many thanks your fruend
 C M Russell

FRIEND TEX, *June 5, 1918*

Charlie likely met Tex McLeod, a bronc rider and fancy roper from San Antonio, at the 1912 Calgary Stampede. There McLeod, on his way to winning the world's champion fancy roper title, $500 in prize money, and a belt, "brought down the house" on three separate occasions by lassoing five riders with a single toss as they galloped by abreast. McLeod was also entered in the bucking-horse competition and made it to the finals, surviving a close call along the way. "Yesterday's audience went home with one firm conviction and that was that professional riders have no bones," the Calgary *Daily Herald* reported. "Tex McLeod rode a genuine 'twister' to a standstill and when the irate animal's bucking repertoire was exhausted it tried to run away. The horse steered for the south fence and collided with a pile of baled hay. Head over heel and all over McLeod went the beast. Almost before the animal was off him, Tex was up on his feet on the pile of hay waving to show that he had not been injured."

McLeod subsequently joined Buffalo Bill's Wild West and during the 1917 season was billed as the champion roper of Idaho. He was still in New York in 1918, so Charlie asked him to look up their mutual friend Ed Borein who had sent him a "McCarthy" ("about fifteen or twenty foot of hair rope" that "was wrapped around the lower end of the noseband under the jaws of the hoss, makin' reins an' a tie-rope," Charlie explained elsewhere) and a pair of tapaderos or wedge-shaped leather stirrup covers designed to protect the rider's feet.

June 5 1918

Friend Fex I got your card
asking how my old hoss is he's standing in
my coral right now but neather him nor
his owner are aneything like booge old Dad time
aint hung no improventinunts on us
judging from your card your still in the big camp
prooving to them Cliff dwelers that a rope will
hold things with out clothes pins
If you ever cut Ed Porines range climb to
that Owls nest of his and Kinder jog his

memory that he owes me som writing
tell him I got the tapadaroes and macarthey
and thank him for me
Several months ago I got a card from you
Saying you was a Dad of a son your
got nothing on us but ours wasent waring
our Iron but his brands vented so he's ours
all right now and we shure love him he's a yearling
past and it keeps us both riding heard
on him

With best whishes to your best half
your self and son from the
Russell family your friend
C M Russell

FRIEND JIM, *August 21, 1918*

Jim Watson, a one-time Great Falls neighbor, evidently was living in Alberta in 1918 when he accompanied the Russells to the Lethbridge Stampede and Fair. Jim served as chauffeur and drove so fast that Charlie felt called upon to chide him gently for "that long ride in a short time which was sum scary." Russell was never fully reconciled to automobiles. He always preferred a horse to a "skunk wagon," and in Great Falls got around on horseback, weather permitting, or streetcar.

George Coffee, who joined Charlie and several others on a hunting expedition into the Rockies in 1922, recalled the trip home "in a big seven-passenger open and unconvertible Pierce Arrow" in *Montana, the Magazine of Western History,* some years later: "[George] Calvert and I occupied the two jump seats in front of the back cushion where Russell and [Jim] Hobbins rode. Snow was falling like big feathers on our shoulders. Calvert and I had taken drinks from a bottle we had left at Gleason's on the way in . . . [and] struck up a few barber-shop strains as the driver swung pretty fast around curves in the road leading out through the foothill jack pines. Charley leaned over and says to Hobbins, 'Jim, if this wagon rolls over you know who'll get killed—just you and me. They've got plenty of song birds in heaven already.' "

Aug 21 1918

Friend Jim I want to
thank you for the good time you gave us
at Lethbridge baring that long ride in a
short time which was sum scary, we enjoyed
every minent.
The above sketch looks like a joke but its a
safe bet its going to be history if Big Jim
Watson dont quit steering that gas eater
down hill on a loose rain.
Maby nobody'l see it but a fiew Bloods
and the cows but they'l have something to
tell there grand children.
Now Jim I've allways been doubtfull about
palmistry an dont clame to know trails I
aint traveled but if the line on your

front foot called by hand readers the
life line is broke in to these palmists
are medison men and fortune tellers;
its a cinch this dont mean you cash in
but your so near across the big range you'l
hear harp music mighty plane
and the under taker will hang around your
camp for quite a while . and when you wake
up you'll be looking for a gentle team and
a buck board, these hosses will be broke
for Grand ma the kind that stays in the road
you can sit on the ranes n look at the scanry,
read the paper or take a nap this sounds
mighty slow but you wont be in no
hurry,

maby you can find a gentle automobile but
I never saw one.
Piine if your stuck to take chances why
dont you try bull doging . it aint so
dangerous and there's more glory in it

of corse a car is easier to throw but it falls
so damed hard that the human generally
takes second money his prize is a wooden
over coat with lots of flowers

Friend Jim I want to thank you for the good
time you gave us at Lethbridge baring that
long ride in a short time which was sum scary, we
enjoyed every minut. The above sketch looks
like a joke but its a safe bet its going to be history
if Big Jim Watson dont quit spurring that gas
eater down hill on a loose rain. Maby nobody'l
see it but a fiew Bloods and the cows but they'l
have something to tell there grand children.
Now Jim I'v allways bein doubtfull about
palmistry an dont clame to know trails I aint
travled but if the line on your front foot called by
hand readers the life line is broke in to these
palmists are medison men and fortune tellers; its
a cinch this dont mean you cash in but your so
near across the big range youl hear harp music
mighty plane and the under taker will hang
around your camp for quite a while. and when
you wake up you'll be looking for a gentle team
and a buck board, these hosses will be broke for
Grandma the kind that stays in the road you can
sit on the ranes an look at the seanry, read the
paper or take a nap this sounds mighty slow
but you wont be in no hurry, maby you can find
a gentle automobile but I never saw one. Jim if
your stuck to take chances why dont you try bull
doging. it aint so dangerous and theres more glory
in it of corse a car is easier to throw but it falls
do damed hard that the human generally takes
second money his prize is a wooden over coat

with lots of flowers Jim you told me that John
Bull wants his Injuns to cut out dancing and put
in all there time plowing, Uncle Sam thinks the
same It aint my place to give advise to these old
Gents an if Im wrong theres no harm meant
our red brothers aint farmers and never will be
but Uncle Sam and Jon Bull both know that as
fighters they aint no push over an if the buffalo
came back tomorrow theyd be damed hard to get
along with theyd raise more hair than they
would wheat why not send these real
Americans across to France an get some old time
trader to mix up some of that buse they ust to
trade at Stand off or Hoop up let them strip
and give them plenty of paint an just before they
went over the top roll out a barrel of Hoop up
trouble maker bust the head in and tell the red
folks its all thaires an Im betting when they
swarm over on the Kizers men them cheese eaters
think sombodys kicked the lid off and all Hells
loose, it will throw a new kind of scare in them
of corse there will be a lot of our red brothers that
wont draw rations no more but its a cinch them
that comes back will be waring german locks on
their leggings well Jim as I cant think of any
more foolishness I close,
My Wife joines me in wishing you all kinds of
luck and we both thank you again for all
your kindness your friend
C. M. Russell

FRIEND CHUCK, *January 15, 1919*

Like any artist specializing in historical subjects and concerned with accuracy, Russell needed a reference "library" of objects as well as books. He surrounded himself with hats, guns, spurs, blankets, Indian crafts, "horse jewelry," gambling devices, whisky kegs, buffalo hooves, and whatever else struck his fancy on his various trips or came into his possession through the kindness of friends. The Mexican handkerchief that Chuck Haas left for him when he popped in for a visit joined Charlie's collection of the "things I like best." Haas, a professional trick roper and an amateur poet, had enlisted for service in the World War I, and Russell told him "if your as handy with a barker [gun] as you ar with a reaitta your a scalp getter."

Charlie's work shows the close attention he paid to details of dress. A phrase like "an old time dally welt rim fire man waring Elk Skin armedos" rolled off Charlie's tongue, and each item mentioned said something special about the cowboy in the sketch. "The cowpuncher east of the Rockies originated in Texas," Charlie explained elsewhere. ". . . These men generally tied, instead of taking their dalliewelts, or wrapping their rope around the saddle horn." Though Charlie has drawn a dally-welter, his cowboy was doubtless a product of the Southwest, where Haas was born, not California, where he grew up.

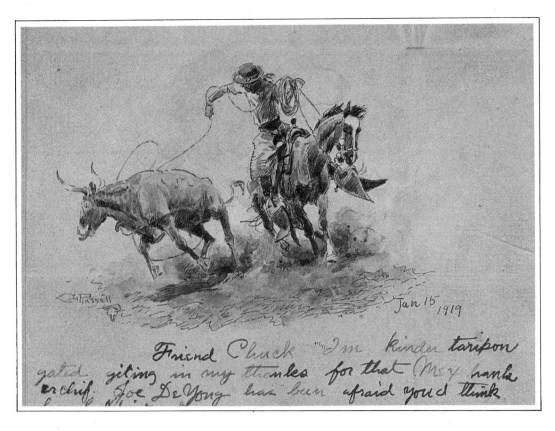

Friend Chuck Im kinder taripon [terrapin]
gated giting in my thanks for that Mex hank
kerchief Joe De Yong has been afraid youd
think he held it out Im sorry you happened in
while I was gon I could have thanked you
better with regular talk its a beauty and I will
always keep it among the things I like best the
above sketch shows the kind of cow puncher I
knew nearly 40 years ago an old time dally welt
rim fire man waring Elk Skin armedos this
speaces of cow dog generly drifted north from
your country traling bands of horses the throw
hes making those days was considered pritty work
roling the loop over the sholders and getting both
fore feet you know all about it but I havent
seen it done for many years judging from them

letters in the lead of your name youv droped
the rope and picked up a gun if your as
handy with a barker as you ar with a reaitta
your a scalp getter Thanking you again and
whishing you a good new Year your friend
C M Russell
I forgot to thank you for the maney cards you
sent your som scucum with a pen yourself

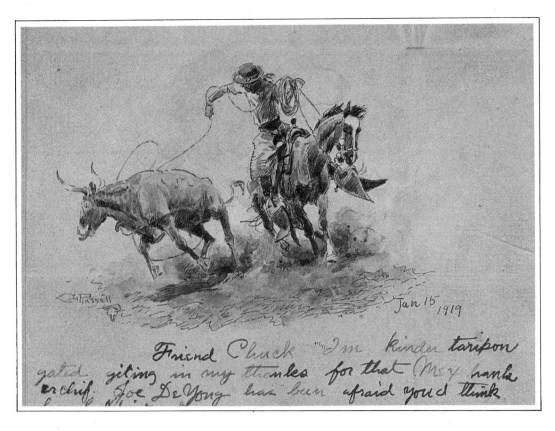

FRIEND FRANK, *January 18, 1919*

A sensitive and modest man, Russell was embarrassed when his work was praised and studiedly indifferent when it was criticized. But some of the disdainful comments directed his way by proponents of "true *aht*" found their mark, and Charlie liked to quote the sentiment attributed to Alfred Henry Lewis that "a critic was to an artist like a flea to a dog—he lived off the dog and didn't do him any good." Thus this letter commenting on a batch of Frank Linderman's stories finds Charlie in a most uncharacteristic role. He was the last person to criticize the work of others. Artists who approached him for advice found him more intuitive than analytical; he taught by example and was better at doing than explaining. Nevertheless, his response to Linderman's tales was both direct and helpful, though he was quick to add to his reservations about two of them that "maby thair better the way you handled them." Overall, his advice was summed up in the revealing phrase "sinch your saddle on romance." Cold fact, experience had taught the Cowboy Artist, was no substitute for emotional involvement, whether the work at hand be a painting or a book.

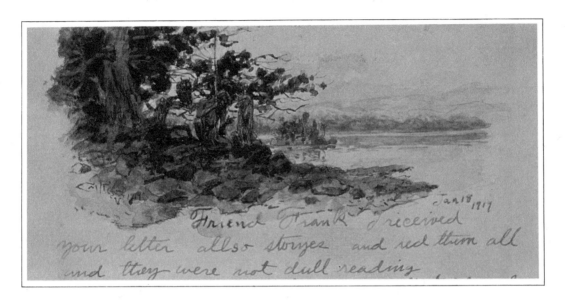

Friend Frank I received your letter allso
storyes and red them all and they were not dull
reading I think you might have made that
Steam boat story longer an pushed in som
romance they were all good but the Crew of
the Tuscan was my chois The Throw away is
realy called a Give away dance it was a
small hunting camp when the dancers went to
sleep little Bird cut all the poneys loos and drove
them away from the lodges holding out one she
had saddled for her self she stole her mans gun
an crouching in the doore of the lodge she threw
som buffalo fat on the fire and when it lit up after
calling hubby a fiew names like lous maggot and
rotten hart she drove a trade ball through him
sending him to the sand hills these are the onley

storyes in the batch that dont suite my taste to an
all spice an at that maby thair better the way you
handled them I will let Miss Trigg look them
over those Na Pa Wolfer and mining stories
you speak of sound good to me and I will be glad
to do what I can with them Your in a good
country to get Na Pa stories that old gent aint
been seen for a long time but I belive hes still hang
round your camp aney how his tracks is mighty
plane when you start those wolfer and miners
sinch your saddle on romance hes a high
headed hoss with plenty of blemishes but keep him
moovin and theres fiew that can call the leg he
limps on and most folks like prancers with best
whishes to you all from we three your friend
C M Russell

FRIEND BOLLINGER, *February 16, 1919*

In January, having suffered a worrisome bout of "flew," Charlie wrote his friend Judge Bollinger that he would be unable to make their usual pack trip into the high country.

The Judge's reply accused Charlie of not giving the "real" reason for his absence from the hunt: the fact that "Mrs. B.," a female acquaintance who apparently fawned over the Cowboy Artist at Lake McDonald the previous summer, did not come along. In rebuttal, Charlie points out that "four Jacks and a Queen" is an unhealthy combination in any game but poker. His drawing illustrates the point. And since Mrs. B. did not buy the painting she had fussed over, she was probably all bluff anyway.

This bantering exchange between Bollinger and Russell was part of the appeal of the annual fall hunts. They provided the opportunity to be away from the womenfolk and talk man-to-man. Bollinger always marveled over how frank Charlie was in discussing his wandering love life before he met and married Nancy. "If confession is rightfully called a bath of the soul," Bollinger wrote, "then Charlie Russell's soul was certainly well bathed. He would confess any time almost, or any place. . . . The state of Montana is in on most of his secrets." Charlie's earthier side has been preserved in some of the watercolors he dashed off for the saloon trade years ago.

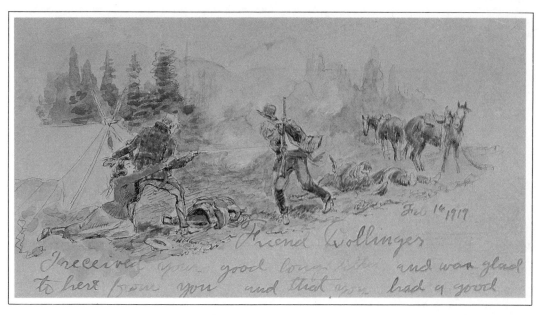

Friend Bollinger I received your good long
letter and was glad to here from you and that you
had a good hunt and brought in meat but
your rong when you think the absence of
Mrs B had anything to do with my not
showing up on that hunt. but I had a hunch
you and Lewis would hold that agin me it
would be a safer bet to play me the other
way four Jacks and a Queen is a good hand
in stud poker but the same number of hes and a
she like Mrs B aint a lucky combination and a
deer hunt might turn to man slaughter
some morning that camp might look like one of
Bill Harts moovis the onley differnce some of
the performers wouldent act no more the above
sketch would go good in the moovies but it would
look like hell in the Great Falls ore Davenport
papers Romance is a beautiful lady that lives
in the book case who can pull aney thing from
a cold deel to murder and get away with it but
shes got a homely sister Reality by name that
hangs around all the time this old girl aint so
lucky let som man make a killing over her and
the Judge tells him where hes going and nobody
knowes his address after that Mrs B dident
take the picture som body in New York bought
it the price was three hundred my oils run
from six hundred to two thousand with best
whishes from all the Russells to you all your
friend
C M Russell

145

Crippled but Still Coming
Flintlock Days—When Guns Were Slow

A measure of Russell's success are the then-princely sums that his work commanded by 1919. The prices quoted to Judge Bollinger—$600 to $2,000 for an oil—were high, but two years later Charlie would receive $10,000 for a single painting. Both Bollinger and John E. Lewis, proprietor of the Glacier Hotel on Lake McDonald, acquired Russell hunting scenes. Bollinger's was a 1913 oil titled *Crippled but Still Coming* showing a furious grizzly charging the hunter who wounded him, while Lewis's was a 1925 watercolor titled *Flintlock Days—When Guns Were Slow* that reached back to the time of the mountain man for its image of the hunter and the hunted at bay.

Flintlock Days—When Guns were Slow, *watercolor, 1925*

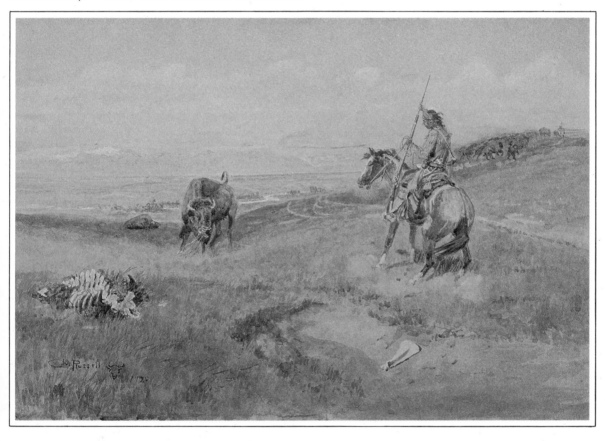

Crippled but Still Coming, *oil, 1913*

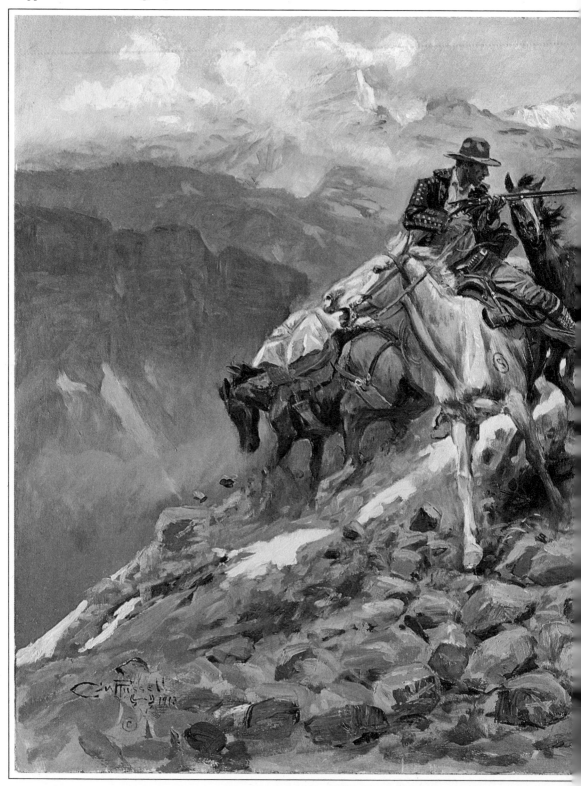

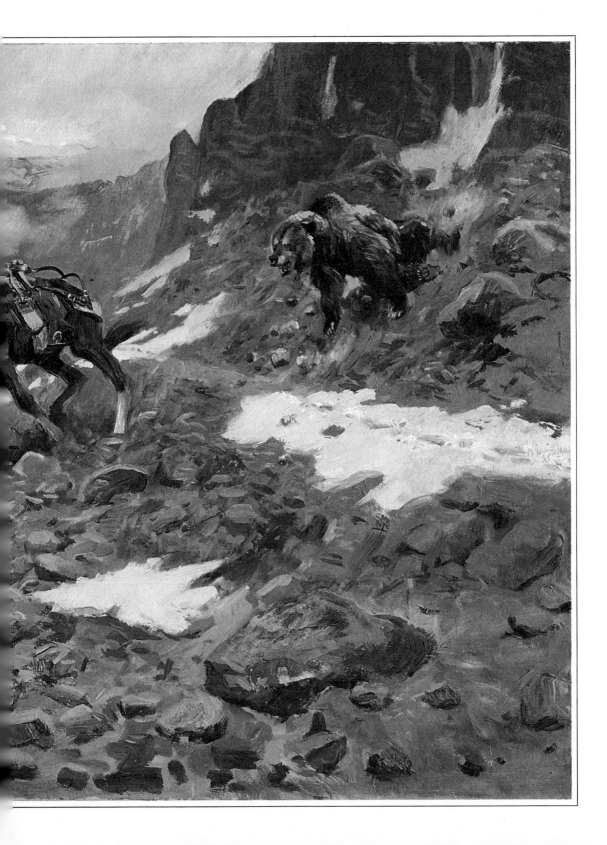

FRIEND GUY, *March 30, 1919*

Early in 1919 Guy Weadick was hired to produce a second edition of the Calgary Stampede. He went through Great Falls in April, promoting what would be known as the Victory Stampede in celebration of the end of the Great War. Charlie was away "repping"—the cowboy term for representing one's outfit, or "brand," at a roundup—at a Montana Stockgrowers Association meeting, but he promised to boost Guy's game. He contributed a colored sketch that became the Stampede's letterhead, and another for the front of a leaflet urging the public to come and see Calgary's "peerless presentation of the Pioneer Past." Weadick himself whipped up a massive promotional campaign on short notice: Calgary's mayor admitted that he was "surprised at the publicity which the event has received throughout the east. Everywhere one hears it discussed. It certainly is a great thing for the city and should receive the heartiest support of every citizen." Nancy and Charlie were again on hand for the big doings, and, as the publicity leaflet had promised, Russell's "famous collection of cowboy paintings, valued at $100,000.00," was "on exhibition at the grounds FREE."

Friend Guy.

March 30
1919

I got your card.
and am glade your coming to our town
but am mighty sorry that I cant be
here as I have all ready promised to
go to Miles City to the Stock growers
Convention which is pulled the 15 and 16
of Aprl So you see we wont get to Shake
hands. but my Wife will be here
and will be glad to see you and yors
I'm surtenly sorry our dates dont
line up but betwine now and 15 Ile
Shure boost your game
I leave here the 14 and return the 17
if I hadent ban invited I'd brake this
date but I was and have axepted so
thairs no chance to back out
when your here I wand you and your wife
to see our boy Jack he dont looke nothing
like me but I dont think folks will hold that
agin him he's all boy and the real thing
with best whishes from me and my best half
to you and yours your friend
C M Russell

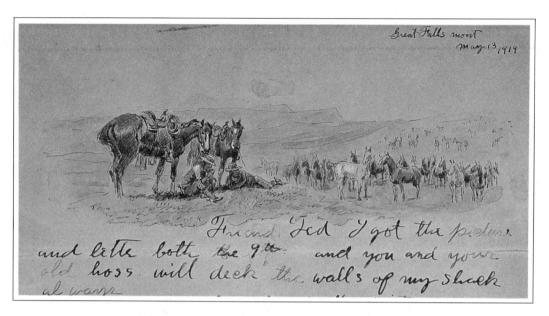

Great Falls mont
May 13, 1919

Friend Ted I got the picture and letter both the 9th and you and your old hoss will deck the walls of my shack al ways

FRIEND TED, *May 13, 1919*

In this nostalgic letter to Edward C. "Teddy Blue" Abbott, Charlie reminisces about cowboy days long ago. The two men met on the spring roundup in 1886. Teddy Blue was repping for the DHS outfit and stayed on with the Judith Basin roundup as a horse wrangler, the same job Charlie held. "That was how me and him got so thick," Teddy Blue wrote years later: "He would leave his horses on one side of the creek and I'd leave mine the other, and we'd get up there on top of a hill, and lay in the shade of our saddle horses, and augur [argue] for hours. We talked about everything we'd ever knowed or done."

Teddy Blue also remembered a discussion about "going Indian." He had been resting in the shade of a big cottonwood tree watching a party of Sioux crossing the Missouri at Claggett, and had fallen into conversation with one of the Indians. Feeling loquacious, the Sioux had expounded upon the glories of life before the white man came. Subsequently, Teddy Blue ran into Charlie and opened with the observation, "God, I wish I'd been a Sioux Indian a hundred years ago."

"Ted, there's a pair of us," Charlie replied fervently. "They've been living in heaven for a thousand years, and we took it away from 'em for forty dollars a month."

Friend Ted I got the picture and letter both the 9th and you and your old hoss will deck the walls of my shack always and when ever I look at the picture my memory will drift back over trails long since plowed under by the nester to days when a pair of horse ranglers sat in the shaddoes of thair horses and wached the grasing bunches of cyuses these cyuses all heard the fiddle, mouth harp and the maney songs sung by thair riders even the war drum of the red men was no novelty to them but this day I speak of it was different every hoss with head up and ears straightened listened for one of the ranglers was a musician and the insterment he played unloded notes on the breaze that would make the cyote taking his day nap in the rim rocks think hes having bad dreams ore wonder if the last feed of cow meat he had wasent over ripe ore maby Mrs Cyote would nag him and say turn over dear your laying on your back and the nois your making will wake the babys the noise maker this rangler played looked like a sweet potato and judging from its voice its a cross bettwin a she caliope wagon and a bull fiddle the owner of this instermint calles it a Bazzas Its a long time ago this happens Ted when we was using our second crop of teeth and now wer both waring our third I remember one day we were looking at buffalo carcus and you said Russ I wish I was a Sioux Injun a hundred years ago And I said me to Ted thairs a pair of us I have often made that wish since an if the buffalo would come back tomorrow I wouldent be slow shedding to a brick clout and youd trade that three duce ranch for a buffalo hoss and a pair ear rings like maney I know, your all Injun under the hide an its a sinch you wouldent get home sick in a skin lodge Old Ma Nature was kind to her red children and the old time cow puncher was her adopted son well Ted Il close the deal bst wishes to you and yors your friend C M Russell

keep on wrighting that cow puncher history it sounds good to me

FRIEND FRANK, *September 22, 1919*

This very human exchange between two old friends suggests that success could be as hard to handle as failure. In late 1917 the Lindermans moved from Helena into a log house above Goose Bay on Flathead Lake. There Frank hoped to earn his living as a writer, though with a wife and three daughters to support times were tough. Consequently, he was counting on a pre-Christmas release of his second, Russell-illustrated collection of Indian tales in 1919 to bring in a little money. Meanwhile, Charlie was experiencing the opposite pressures of success. It was out of friendship that he had agreed to illustrate Linderman's book, and he did not appreciate the urgency of the situation. Charlie's delay in completing the illustrations delayed the release of Frank's book, and on September 19, exasperated and hurt, Linderman wrote demanding the return of "all my manuscript of all tales and Indian stories. I note that you said there was work you had to get out on time. You had my stories since last March and wrote me that you had started on pictures last May. I guess I don't count. If you ONLY had guts enough to have told me you wouldn't do my stuff I'd have been thankful to you for now I shall have to wait another year but not on you."

Linderman's blast and Charlie's reply were more wounded than bitter in tone and the exchange cleared the air. When *Indian Old-Man Stories: More Sparks from War-Eagle's Lodge-Fire* was released the next year, it contained its full complement of Russell illustrations—nine paintings and ten pen-and-ink drawings.

15-4

Sept 22 - 1919

Friend Frank I got
your note an am sorry
you got snuffy

you say I dident have
guts but I dont notice
where your shy any
the way you com back

I am sending you four
pictures to prove that I
was working you can keep
them they aint worth a dam
to me

I am enclosing all $storys$
If you hadent been up
aganst a string of hard
luck I might get sore
at you Im sorry not
Sore

Long to wilb factory

your Friend
C M Russell

I allso have
4 pen sketches

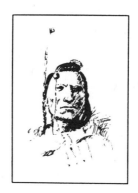

FRIEND FRANK, *n.d.*

Frank Linderman and Charlie Russell were both outspoken advocates of Indian rights, and each detected in the other a trace of the native. In this undated letter thanking Linderman for the gift of a pin made from a gemstone, Charlie reverts to the terms of the Old-Man tales Linderman recorded. His sketch shows Napi, the Indian Old-Man, who was the Cree and Chippewa god of creation and played the part of a divine prankster and fool in their legends. But as a thief, Charlie maintains, he could not hold a candle to the white man who in his greed tore the earth apart looking for "the Old mans caches" and forced Napi to flee the world in embarrassment at such a shameful spectacle.

CHAS. M. RUSSELL
GREAT FALLS, MONTANA

Friend Frank I thank you
for the pin it is fine I will always keep it
you spoke the truth when you said the old man had
hidden many beautiful things few would guess that
the stone you picked up held anything inside
but Napi was a thief and as he made the world
and all the creatures he judged them by himself
so he left few slinuey things to tempt them
The men he made were satisfied with what laid on
the surfase
as few shells elk teeth an claws were there jewels
but like himself they were meat eaters an thieves
the grass eaters were the onley honest ones

but his caches would have lain till the end of time
Had not another man come. one he did not make –
a greater thief than all of his
It was natures enemy the white man
This man took from under and more he stole from
the water the sky. He was never satisfide
It was he who raised the Old mans caches an
still hunts the few that are left
When Napi saw the new thief he hid his fase in
his robe and left this world
and I dont blame him

Thanking you again
Your friend
C M Russell

FRIEND CON, *October 15, 1919*

By 1919 Con Price had moved to California, adding to the number of good friends the Russells would want to visit when they took their first extended vacation there the following spring. Charlie remembered the distinctive cowboys who hailed from the Golden State. In "The Story of the Cowpuncher," reprinted in *Trails Plowed Under,* he had described them as men who used "centerfire or single-cinch saddles, with high fork an' cantle; packed a sixty or sixty-five foot rawhide rope, an' swung a big loop. These cow people were generally strong on pretty, usin' plenty of hoss jewelry. . . . Their saddles were full stamped, with from twenty-four to twenty-eight inch eagle-bill tapaderos. Their chaparejos were made of fur or hair, either bear, angora goat, or hair sealskin. These fellows were sure fancy, an' called themselves buccaroos, coming from the Spanish word, *vaquero.*" Now, though he certainly had not forgotten "them senter fire long reatia Buckaroos," he had assumed that California's cattle industry was limited to dairy cows. For that matter, the industry was not much healthier in Montana, and severe drought had only added to the cattlemen's woes.

Charlie found an improbable moral in all this. The reformers had won. Prohibition was a reality and Montana, like the rest of the country, was going dry. But to Charlie it was as if the reformers had achieved their victory by upsetting the natural order of things, and an angry Providence—responsive to Charlie's tolerant view of morality rather than the prohibitionists' narrower one—had decided to extract a vengeance in kind. So the Almighty "turned the water of" and the nesters, whom Charlie lumped with the reformers, paid the same price as the cattlemen they had displaced.

I suppose this would be an easy throw
for eney of them skin string
Buckroos

C. M. RUSSELL
GREAT FALLS MONTANA

October 15
1919

Friend Con a frew days
ago I got your letter and one a long time ago
which makes me owe you two I rote you one
since you went down to Cal but you never said
you got it

I'm glad you like that country and from what you
say its a good one . long ago I ust to hear
them senter fire long reatia Buckaroos tell
about Califonia rodaros but at this late day
I dident think thair was a cow in Cal that
wasent waring a bell . Poor old Montana is the
worst I ever seen an Ive been here forty snows
the reformers made her dry and the All mighty
throwed in with them and turned the water of
an now thair aint enough grass in the
hole state to winter a prarie dog
but if the nesters could sell thair tumble weed
at a dollar a tun thair all Millionairs
ist shure a bumper crop

I saw Jonny Rich not long ago hes running
a moovie show in Lewistown and dooing well
he says last winter when the flew hit his
town the Doctor advised him to take three

C. M. RUSSELL
GREAT FALLS, MONTANA

mouths full of booze a day to head off the
Sickniss to make shure how much hes taking
Jonny measurs a month full which he says
is an even pint he followes the Doctors orders
to a hair and the Flew never tuched him said he
felt fine all the time but after about a month
of this treatment he got to seeing things that aint
in the natural history. one day he saw a Poler
Bear sitting on a hot stove wearing a coon skin coat
and felt boots eating hot tommales

I went to the stampeed at Cangary this fall and it
was shure good saw a frew old timers some old
friends of yors

Charlie Furman said a long time ago he had a
horse that he was afrard of one day hes riding
this animal kinder carful with feet way out and
choking the horn when suddenly with out cause this
hoss starts playing peek a boo about the second

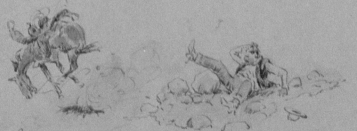

jump Charly is unloded among a crop of bolders
an he tells me hes numb all over and feels like every
bone hes got is broke in three places but when he starts

coming back to life if his hart gets big and all of
a sudden he remembers he aint give Con Price
no wedding present so next day he saddles a
gentle horse and leads peek a boo over and
presents him to you

Furaman says he dont see you for quit a while
but when he dos meet you you say some things
that I cant put in this letter and you said if
ever you married again that he needent send
no presents

I an sending you a couple of pictures of Jack
Mame sent you som last winter in a Christmas
pacage for Leslie but I guess you dident get
them hes shure a fine boy and lovers horses
hes got a rocking horse and two stick horses an
he rids the tail off the hole string I still have
a caple of old cyuses and some times I take
him in the saddle with me and it shure tickles
him we may come to Cal this winter if we
do wel try and look you up Iv got a long
range cousin in that country named Philips
that is running cows down thair some where
well Con Il close for this time
 with best washes from
 the three of us to the three Prices
 your friend
 C M Russell

FRIEND JOHN, *n.d.*

Charlie tried to be tolerant of others' opinions, but he found that Montana's "moral leaders" were making it hard for him. His letter to John B. Ritch shows the strain. Charlie was never blunter in stating his allegiance to the past and his disgust with the "newcomers" who had spoiled Montana in the name of improvement. He would rather spend eternity in hell with some real old-timers, he told Ritch, than in heaven with "eight billion winged nesters."

Johnny Ritch was an old-timer himself. He arrived in the Judith Basin in 1885 and worked as a cowboy, miner, and journalist. He wrote verse on the side and was known locally as "the Poet of the Judith." In 1917 he read the following lines at a surprise birthday party honoring Charlie:

> *Let his roundups ride great circles,*
> *Gath'ring in the time-tossed strays,*
> *Miners, trappers, "breeds" and hunters,*
> *Gamblers from their sodden plays, —*
> *All the types that fill his pictures*
> *Of those golden, early days.*

Such bursts of nostalgia aside, Ritch, as clerk of the Tenth District Court for eight years and operator of a Lewistown movie theater, had identified himself with Montana's progressive element. His poem "Shorty's Saloon" (with calligraphy by Josephine Trigg) paid tribute to some hard cases from "those golden, early days," however, and that tipped Ritch's hand. In his heart, Charlie maintained, he was an ally.

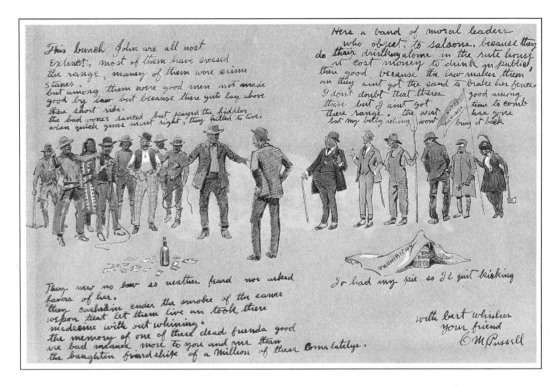

Friend John
I am sending Shorty and I want to say its your
best you can saw off all you want to to
these new comers how you love the dry lander an
how over joyed you are at seeing Gods grass
turned to wheat, but these verses about Shorty
tiped your hand. your a liar by the clock. Shorty
an most of his bunch have cashed in an it
aint hard guessing there home address but
when I cross the range Il pass up eight billion
winged nesters to shake hands with Shorty. an if
I dont find him Im going to be plenty lonsum.
a regular man could stand a hol lot of heat
with a Pal like Shorty. His kind heeded no
commandments, but if weighed his good
deeds would over balince his sins, an I think,
Johnny, when you face Old St Peter you wont be
inquiring for non of the new booster bunch. Youl
be asking the where abouts of Slick, Slim, Shorty,
Bowlegs, Brocky, Pike,
Bed rock, Pan handel, Four Jack Bob, Jim
the Bird, P P Jonson, Bench legs, and Fighting
Fin am I right? This bunch John are all most

extinct. most of them have crossed the range,
maney of them wore crime stanes, but
among them were good men not made good by
law but because there guts lay above there short
ribs. the bad wones danced but payed the
fiddler when quick guns ment right, they killed to
live. They new no law so neather feard nor
asked favers of her. they cashed in under the
smoke of the same wepon that let them live an
took there medecine with out whining. the
memory of one of these dead friends good ore bad
meanes more to you and me than the baughten
friendship of a million of these Comelatelys.
Hers a band of moral leaders who object to
saloons, because they do thair drinking alone in
the rute house it cost money to drink in
publick, there good because the law makes them
an they aint got the sand to brake her fence. I
dont doubt that theres good among them but I aint
got time to comb there range. the west has gone
but my belly aching wont bring it back Iv had
my pie so ll quit kicking with best whishes
your friend C M Russell

No fine drinks adorned that primitive bar,
Just "licker" was served, and that seemed by far
The properest stuff in a place, you'll agree,
Where life flowed and ebbed like the tides of a sea,
Unfettered by care, unmeasured by time,—
Where Innocence formed its first friendships with Crime,
Where Bacchus' wild court held ribaldrous sway,
And Shorty, on shift, stood waiting to say,
 "What's yours, Pard?"

By the trails to the Past, on the Plains of No Care,
Stood Shorty's saloon, but now it's not there,
For Shorty moved camp and crossed the Divide
In the years long dim, and naught else beside
A deep brand on Memory brings back the old place,—
Its drinks and its games, and many a face
Peers out from the mists of days that are fled,
When Shorty stood back of his bar, there, and said,
 "What's yours, Pard?"

CHARLES F. LUNNIS, *March 10, 1920*

By 1920 Charles F. Lummis was a father figure to those who loved the Southwest. In 1884–85 he had hiked the entire distance—some 3,500 miles—from Cincinnati to Los Angeles, where he had assumed the duties of city editor at the Los Angeles *Times*. A few years later he was roaming in New Mexico, the country he subsequently popularized nationally as "the land of poco tiempo." By 1894 he had settled permanently in the Los Angeles area, building his own stone house, El Alisal, near Pasadena. His writings and the periodical he edited for many years, *Land of Sunshine* (later, *Out West*), promoted the southwestern ethos and Lummis's favorite crusades. He fought doggedly for the preservation of California's Spanish heritage, especially the missions, and was active in the campaign for Indian cultural rights at a time when the Government was committed to a policy of assimilation. Two of Charlie Russell's artist friends, Maynard Dixon and Edward Borein, were married in "Pop" Lummis's home, and it was inevitable that Charlie would meet Lummis during his stay in California and, recognizing a kindred spirit, call him Friend.

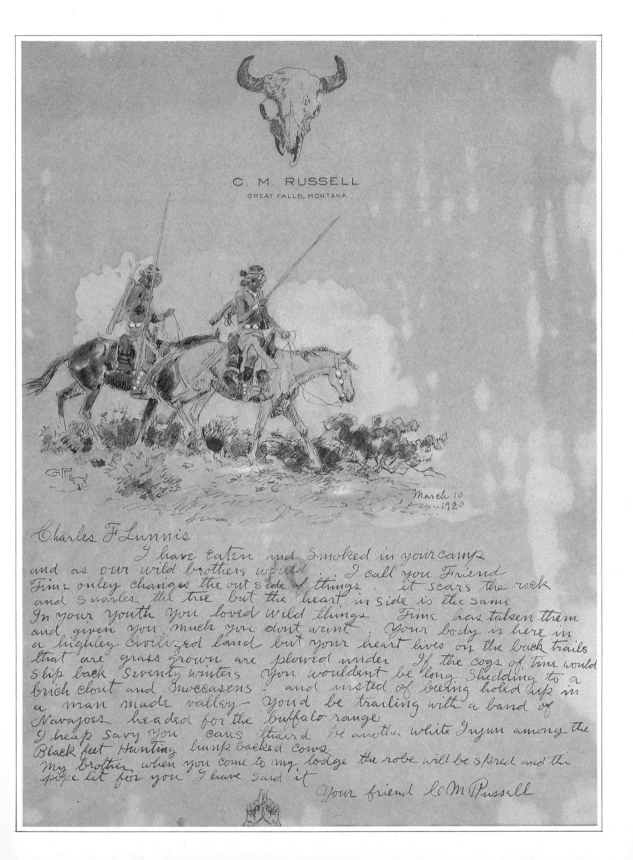

C. M. RUSSELL

GREAT FALLS, MONTANA

March 10
1920

Charles F Lummis
I have Eaten and Smoked in your camp
and as our wild brothers would it I call you Friend
Time onley changes the out side of things it scars the rock
and snarles the tree but the heart in side is the same
In your youth you loved wild things Time has taken them
and given you much you dont want Your body is here in
a highley civilized land but your heart lives on the back trails
that are grass grown are plowed under If the cogs of time would
slip back seventy winters You wouldent be long shedding to a
brich clout and moccasens and insted of beeing holed up in
a man made valley — youd be trailing with a band of
Navajoes headed for the buffalo range
I heap savy you cans theard be another white Injun among the
Black feet Hunting hunp backed cows.
My brother when you come to my lodge the robe will be spred and the
pipe lit for you I have said it
Your friend C M Russell

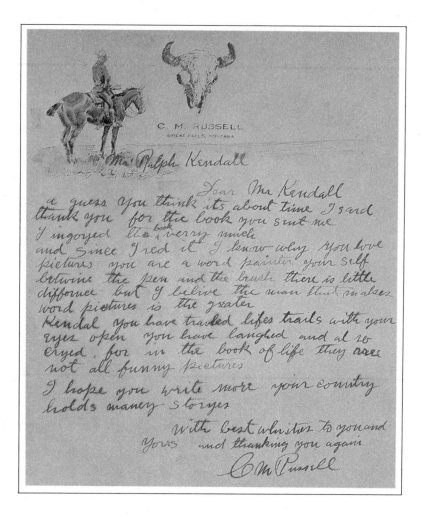

C. M. RUSSELL
GREAT FALLS, MONTANA

Mr Ralph Kendall

Dear Mr Kendall
a guess you think its about time I said
thank you for the book you sent me
I ingoyed the book verry much
and since I red it I know why you love
pictures you are a word painter your self
betwine the pen and the brush there is little
diffornce but I belive the man that makes
word pictures is the greater
Kendal you have traveled lifes trails with your
eyes open you have laughed and al so
cryed. for in the book of life thay are
not all funny pictures
I hope you write more your country
holds maney storyes

With best whishes to you and
Yours and thanking you again
C M Russell

DEAR MR KENDALL, *ca. 1919*

Ralph S. Kendall, who served with the Royal North West Mounted
Police from 1905 to 1910, met Charlie Russell at the 1912 Calgary
Stampede. They formed a "solid friendship," and shortly after the
1919 Stampede Kendall presented Charlie with a copy of *Benton of
the Royal Mounted* (1918), the first of his two novels about the "scarlet
force." In the foreword he expressed sentiments of the sort Charlie
never tired of hearing—nostalgia about the "years gone by" and loyalty
to old comrades, "men of a type fast disappearing, with whom any
one would have been proud to associate."

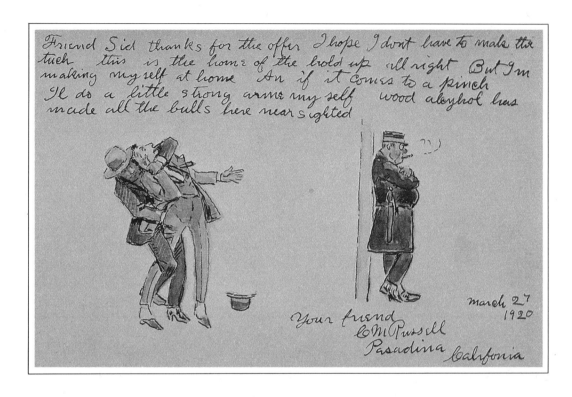

Friend Sid thanks for the offer I hope I dont have to make the trick this is the home of the hold up all right But I'm making my self at home An if it comes to a pinch I'd do a little strong arme my self wood alcohol has made all the bulls here near sighted

Your friend
C M Russell
Pasadena California

march 27
1920

FRIEND SID, *March 27, 1920*

Writing Friend Thed—Theodore Gibson, the senator's son—from Pasadena, Charlie said he thought the area was well named "the worlds pick nick ground," because "theyv shure picked a nick in my bank role."

Sid Willis, after seeing the letter, hastened to offer a loan, which Charlie, not really hard up, humorously refused. He would do a little mugging if he had to.

It must have amused both men to remember a time not so long distant when the struggling artist really was pinched and Willis more than once a friend in need.

FRIEND ED, *April 5, 1920*

One bonus for vacationing in California was the chance to visit several friends Charlie had made in New York City. A few Wild West show cowboys and stage performers like Will Rogers had become part of the Hollywood scene, while artists like Maynard Dixon and Ed Borein had relocated permanently in their native state. Borein, an Oakland boy who became a vaquero on the Jesus Maria Ranch near Santa Barbara in the 1890s, turned to art and was an established illustrator and etcher in New York between 1907 and 1919. Charlie met him there; as ex-cowboys trying to make a living as artists, they were naturally drawn to each other.

Ed, Charlie, and Will Rogers did eventually get together during the California vacation, and one who attended the party remembered it as "a bright and entertaining evening," filled with good stories well told and a special performance of part of Rogers's Ziegfeld Follies routine.

Ed enjoyed letter-writing about as much as Charlie did, so their exchanges tended to be brief.

C. M. RUSSELL
GREAT FALLS, MONTANA

Apral 5
1920

Friend Ed
 I received your
letter the last one bent now
at San Diego have met many of
the movie folks here and have had a good
time we expect to leave here the 15 But dont let
our coming hed off aney trips you were going to
make
 With best whishes from us
 your friend
 C M Russell

171

FRIEND PHIL, *April 10, 1920*

Ten years had passed since Philip Goodwin last "loaded his war bag" and drifted to Montana to spend a summer with the Russells, but he was still a welcome guest. As his first long vacation in California neared its end, Charlie obviously looked forward to getting back home and spending the summer at Lake McDonald. California had left him unimpressed. It was "strictly man made." To an illustrator like Goodwin who specialized in hunting scenes and wild life in its natural habitat, California had nothing to offer. "Nature aint lived here for a long time," Charlie reported, "and thats the old lady Im looking for."

M. RUSSELL
GREAT FALLS, MONTANA

As I imagine San Pedro
in 1820

Pasadena Cal
April 16
1925

Friend Phil I got your
letter and sketch so long ago I'm almost ashamed to answer it
but I was glad to here from you saven if I am slow about saying so
you will see I'm down among the roses this is a beautiful country all
right but its strictly man made I think in early days it was
a picture country before the boosters made real estate out of it but I'm
about 100 years late the live oak is a native of this country and good
to look at but it didint looke warm enough so the land boomer stuck
in palm trees and plenty of roses this is bait so when the northern
traveler looks out of the steam heated Pulman and sees all these palms
and flowers he thinkes hes in the tropicks when the train stops he
unlodes and prepares to camp if its a warm day he dont but the groun
tell sombodys sells him what he thinkes is an oring grove but when it
develps its lemons this is the birth place of Bunko and bungiloos
Phil if I was painting frute flowers automobiks are flying maslines this
would be a good country but nature aint lived here for a long time
and thats the old lady I'm looking for
Phil its mighty near time you mad another trip west I think about
the middle of July yound better load your war bag and drift to Belton
my shack will be open for you Lake McDonald is not what she ust to
be but thare are still some wild skots near the deer are quite tame and
we see them often if you com wel take another trunk line trip
think this ove Phil
 with best wishes to you and your Mother
 from us all your friend
 C M Russell

we leave for home
next week

FRIEND BOB, *April 14, 1920*

Time did not dim Charlie's affection for old friends like the Bob Thoroughmans. In 1862, at the age of fourteen, Thoroughman had journeyed west to Denver, later following the news of the Alder Gulch gold strike up to Virginia City. He worked as a freighter and cowboy before his marriage in 1870, and subsequently ranched in the Chestnut and Sun River Valleys south and west of the site of Great Falls. Like Granville Stuart and Robert Vaughn, Bob Thoroughman was a real Montana pioneer, and Charlie admired his kind and the "true unselfish wimen and mothers who shared equely all hardships of the man of thair choise." At the time Charlie penned this letter of congratulations to the Thoroughmans on their golden wedding anniversary, he and Nancy were just a year away from their own silver anniversary—proof positive that the preachers who married both couples knew how to tie neck knots. (Necking, in cowboy parlance, was the practice of tying an unruly horse to a gentle one. As a veteran horse wrangler, Charlie knew all about it.)

M. RUSSELL
GREAT FALLS, MONTANA

Pasadena Cal April 14 1920

Friend Bob the distance bared us from your
Golden Wedding but thair is no trail to rough ore long to stop
the travel of the good wishes of our harts to friends
so our harts were with you at the scool house. Bob like all
your friends we are glad we knew you. Your kind were never
plenty. but thair scarce these days. Invention has made it
easy for man kind but it has made him no better. Machinery
has no branes. A lady with maniekured fingers can drive an
automabele with out maring her polished nailes
But to sit behind six range bred horses with both hands full of
ribbons these are God made animals and have branes. To drive
these over a mounten rode takes both hands feet and head in
its no ladys job. To sit on the nie wheeler with from ten
to sixteen on a jirk line ore swing a whip ove twenty
bulles string on a chane an keep then all up in the yoke
took a real man. And men who went in small partys
ore alone in to a wild country that swarmed with
painted hair hunters with a horse under thame and a
rifel as thair pasporte These were the kind of men that
brought the spotted cattle to the west before the humped
backed cows were gon. Most of these people live now
only in the pages of history. but they were regular men
Bob and you were one of them some of them had wives.
mad of the same stuff as thair husbands true unselfish women
and mothers who shared eqnely all hardships of the man of
thair choise and desurved realy more prase than thair
husbands Bob you must have booked good to Miss Bickett
for her to tie on to a cow traiking drifter like you.
Girls were scarce them days and Im betting thair were
plenty of horses tied to Old Doc Bicketts hich rack whos
riders claimed to be looking for horses but were realy wife
hunting its a sinch She had pleanty to pick from
But fifty years on a preachers tie proves that she roped
the one she wanted I think Bob you were a bunch quiter
till that preacher necked you and judging from the way
the tie lasted he knew how to tie a neck not
with best whishes from me and the one Im neded
to to you and yors your friend
C M Russell

DEAR FRIENDS, *September 15, 1920*

As Russell's fame spread, there were more demands on his time than
he could handle and he had to turn down some of the many invitations
he received to attend fairs and rodeos throughout the West. In Sep-
tember, 1920, he had a good excuse for missing the Montana State
Fair at Helena since he had just had some teeth pulled. Now, he
conceded, he was homelier than "a well known Saddler" in Helena—
a reference to his old friend Ben Roberts (in whose home he and Mame
were married) and an anecdote that has been told many different ways
over the years. About 1882, while visiting in Helena, Charlie walked
up to Roberts, whom he had never met, addressed him by name and
introduced himself. When a surprised Roberts asked how he knew him,
Charlie replied: "Well, they told me when I found a man in Montana
as ugly as I am, it would be Ben Roberts." From that moment on, one
of Roberts's daughters recalled, the two men were the best of friends.

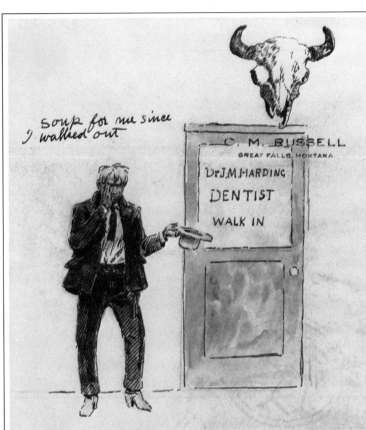

soup for me since
I walked out

C. M. RUSSELL
GREAT FALLS, MONTANA

Dr. J. M. Harding

DENTIST

WALK IN

Sept 15 1920

Dear Friends I want to thank you for
the kind invitation to join you at the Fair
The above sketch will tell why I wasent thair. It would be an
honer and I would have been proud to ride with cow men of my
country led by our Governor but I dont think that an old soup
eating hoss wrangler would ad to the looks of a bunch of beef eating
cow punchers
I never was long on looks and in the old days it was said by many
that I was the homelist human in the Taritory excxpt a well known
Saddler in your town he lives thair yet and the last time I saw
him time hadent hung no ornaments on him I still held the edg
but since that tooth hunter tore my face props out that saddler
is hansom hes got it all ove me

Thanking you all
your friend
C M Russell

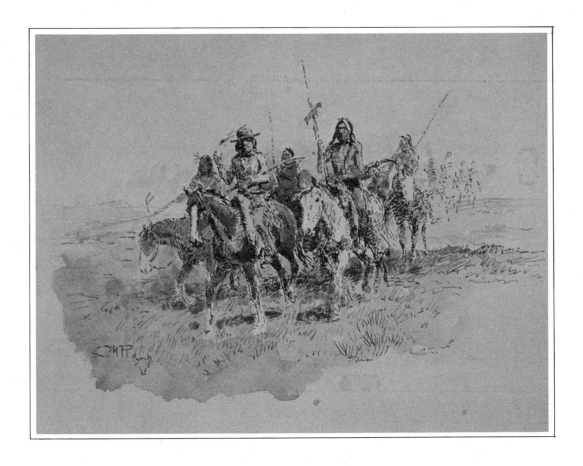

FRIEND ARMSTRONG, *April 9, 1921*

Charlie never ceased mourning the past. Sometimes he was angry about the changes that had occurred around him. At other times his mood was mellow and reflective. This elegiac letter to W. M. Armstrong, a Los Angeles businessman, was occasioned by a request to extra-illustrate a copy of Francis Parkman's classic narrative of his adventures out west in 1846, *The Oregon Trail.* Charlie obliged, and ended up doing the same assignment for some other friends in 1923, when he added eleven watercolors to the Frederic Remington-illustrated edition of Parkman's book. Charlie took particular pleasure in the task because he had a romantic affinity with the West of the mountain man and the Oglala Sioux described in *The Oregon Trail.*

W.M. Armstrong
 Los Angeles Calif
 April-7-1921

Friend Armstrong
 I call you this as I count all those
who love the old west friends
The brown heerds and wild men that Parkman
knew and told of so well have gon
The long horned spotted cows that walked the
same trails their humped backed cousins made
have joined them in history. and with them
went the wether worn cow men
They live now onley in bookes. The cow puncher
of Forty years ago is as much history as
Parkmans Trapper . The west is still a
great country but the picture and story
part of it has been plowed under by the
farmer . Prohabition maby made the west
better . But its sinch bet Such Gents as
Trappers Traders Prospectors Bull whackers
Mule Skinners Stage drivers and Cow puncher
dident feed up on Cocola ar Mapel nut
Sundais
To make sketches in Francis. Parkmans Book
has been a pleasure to me
When I read his work I seem to live in his
time and travel the trails with him
 Whishing You and Yours health
 and happyness

Your friend
 C M Russell

WE MEET AGAIN DOUGLAS FAIRBANKS, *1921*

A long-time movie addict, Charlie thoroughly enjoyed meeting some of the people he had watched on the screen. Most of the Hollywood types he traveled with were in western films. Douglas Fairbanks and his wife Mary Pickford were another matter, members of Hollywood royalty at a time when movie stars were national idols. Consequently, Montana newspapers eagerly reported the Russells' meeting with Fairbanks in May, 1921, on the set of *The Three Musketeers,* and Nancy felt the elation of having arrived at last. Her critics have observed that she had much to gain from such contacts, since Hollywood money meant more sales and higher prices. But the relationship was not one-sided. Mary Pickford remembered in her book, *Sunshine and Shadow,* that "people of attainment" fascinated Fairbanks. "He sought them out, not because he was a snob, but because of his lively interest in how they had made their names; how they accepted their successes; how it had influenced them." Charlie Russell was a case in point. His letter to Fairbanks is flattering but not obsequious, and is fully consistent with his character, since it contains one more pitch on behalf of the Old West.

The bronze equestrian statue of the insouciant Fairbanks as D'Artagnon was sculpted in 1924.

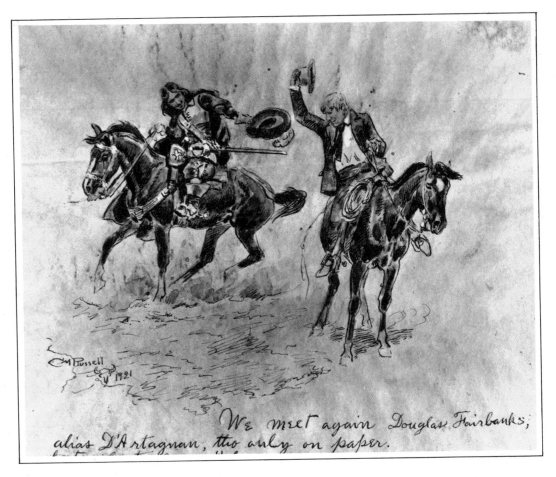

We meet again Douglas Fairbanks; alias D'Artagnan, tho only on paper.

We meet again Douglas Fairbanks, alias D'Artagnan, tho only on paper. My hats of to you I have seen you under many names and you have worn them all well—an actor of action always—And now since you have back tracked the grass grown trails of history and romance I know that D'Artagnans name will fit you as well as his clothes. But Doug don't forget our old west. The old time cowman right now is as much history as Richard, The Lion Harted or any of those gents that packed a long blade and had their cloths made by a blacksmith. You and others have done the west and showed it well but theres lots of it left, from Mexico north to the Great Slave lakes the west was a big home for the adventurer—good or bad—he had to be a regular man and in skin and leather men were almost as fancy and picturesque as the steel clad fighters of the old world. The west had some fighters, long haired Wild Bill Hickok with a cap and ball Colt, could have made a correll full of King Arthurs men climb a tree. your friend C. M. Russell

FRIEND GUY, *November 23, 1921*

After the Victory Stampede of 1919, Guy Weadick was out of the rodeo business for three years. He and his wife bought a ranch on the Highwood River in the foothills of the Rockies, near Longview, Alberta, in 1920. Since their cattle wore the $\frac{T}{S}$ brand their spread was known as the $\frac{T}{S}$ Ranch, as Charlie has designated it in his letter. But it was also a dude ranch, featuring trail rides through the foothills and into the mountains. Charlie, who could be caustic where tourists were concerned, was considerably gentler here. But then, as Irvin Cobb pointed out in *Exit Laughing,* Charlie's war had always been with a certain *type* of tourist, those who "defiled beauty spots with their leavings of banana peels and dill-pickle butts and Sunday supplements and empty pop bottles . . . whose carelessness in the matter of camp-fires and lighted cigarette ends had turned thousands of square miles of virgin timber into smutted desolations . . . who desecrated natural grandeur by splattering their inconsequential names on noble land-marks and tall cañon walls—well, for these offenders language failed him." He had no trouble drawing them, however.

November 2"
1921

Guy Weadick
T
S Ranch
Longview
Alberta

Friend Guy I got your
letter and am glad to here you are doing so well
with your ranch it pleases me plenty to know that
thair is so many men and wimen that will quet a gas
wagon and a good road and ore wilen to look at the world
with a horse under em . and where you live Guy if they'l step
in the middel of a hoss you can show folks the top of America the
wildest the biggest and for a nature lover the best part of it
In tame countrys on a good road an autos all right but
if your hunting for aney thing wilder than a Doctor take a horse
I suppose by this time your on the rode I'm sending you a book
which I hope you enjoy My wife and I leave for Denver tommorow
morning so this is a baisy camp we will returne in about two weeks
Thanks for the invite to viset the T
S Ranch we might
do that some time with best whishes to you and yours
from us all Your friend C M Russell

C. M. RUSSELL
GREAT FALLS, MONTANA

Friend Jake I'm slow answering

FRIEND JAKE, *n.d. (ca. 1922)*

The recipient of this letter was probably Jake Hoover, the "all around mountain man" who befriended Charlie when he first came to Montana and taught him something of nature's secrets. Hoover had since moved to Seattle, where he operated a boating business and supposedly knew the fish of the inland waters around Seattle as well as he once knew the habits of Montana's wild animals. Though the letter is undated, it comes from the early 1920s. Charlie, who often attended Indian celebrations and had just returned from watching one at Browning on the Blackfoot Reservation just east of Glacier Park, was amused by the thought that Prohibition had merely managed to reverse the direction of the whisky trade. In the old days, American traders smuggled liquor into Canada and sold it to the Indians out of such establishments as Fort Whoop-up at the junction of the St. Mary and the Oldman Rivers and Stand-Off at the junction of the Kootenai and Belly Rivers. Now, Charlie observed, the traffic was flowing south, the only difference being that "hossless wagons" now carried the goods.

Friend Jake I'm slow answering your letter but I hope mine is as welcom as yours was I have just returned from the Park stoped at Browning on my way home and took in a celebration the red folke were pulling off they had rases and som good riding of corse thair was dansing a fiew of the dancers were stripped and wer giving it scary the same as back in buffalo days In these moril Shimmey shaking times I wondered that the good white people would allow this but while these wild immodist saviges are twisting and prancing with bells and paint the reformers are bunched in the town hall shimmeying to a jaz band most of the ladyes that have gon to a clinch with men use thair paint more artistick than thair red sisters but just as much of it and the clothes thair waring wouldnt more than make a clout for the wildest buck in the Black foot camp While Im watching the Injun dance thairs one buck swings in close to me and my nose gits his breath its like a breese from Canada its a sinch it aint CoCola thats making him dance A fiew minuts later I meet a Breed friend I savy now whats putting wild stuff in this Injun dance this Breeds Dad in the old days usto smugle booze in to Canada to the Bloods the son is keeping the trail of his dad but they travel different his old Dad slipped in to Hook up ore stand off with a string of pack horses But the half Ingun son crosses the line in a hossles wagon well Jake this camps quiet and as thairs no news I close with best whishes to you and yours your friend
C M Russell

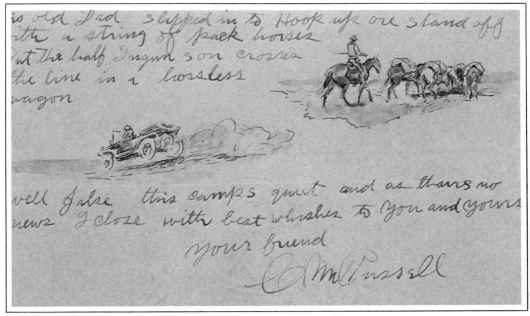

FRIEND DICK, *February 8, 1923*

Russell bought his artist's supplies and had his pictures framed at The Como Company on Central Avenue in Great Falls. Carter Rubottom, whose father owned The Como, remembered that "hardly a week passed when Russell was in town and he did not drop in to swap stories with the boys in The Como back room." This was where the picture framing was done and paintings were crated for shipment to exhibitors or buyers. Usually they were placed on view in the shop window first. "I have seen as many as eleven wonderful C.M.R. oil paintings," Rubottom recalled, "in our windows at one time."

Richard O. (Dick) Jones was one of the picture-framers at The Como, and over the years became an intimate of the Cowboy Artist. Despite Charlie's warning that sunshine in southern California "is like near beer it looks good thats all," Jones moved to the Los Angeles area in the early 1930s and eventually became the country's leading purveyor of Russell prints.

C. M. RUSSELL

GREAT FALLS, MONTANA

Feb 8th
1923

Richard Jones

Friend Dick you will see
by the sketch I am among the palms and flowers
but Im still packing coal Sun shine in this country
is like near beer it looks good thats all
in most countrys frowers and palm trees mean warmth
but that dont go here any thing that grows here would
thrive any where in Glacier Park
tell Bull Trout thars lots of fishing here from shark
to smelt the ocion aint fifty yards from my
door Frank Linderman and me are going clam fishing
in a few days Frank lives next door we get these with
a shovel and working around a furnis so many years
Im shure handy with that tool when they fish with a shovel
its a cinch Il bring back the goods Dick
I would like to step in to the Como right now give my
regards to the bunch including the young lady
 best whishes to you and yours
 if you have time tell me your frend
Address the news C M Russell
509 East Cabrillo Bd Boulevard
Santa barbara

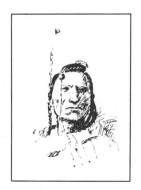

Note: To Whom It May Concern, *November 18, 1923*

Until the Rocky Boy Reservation was created in 1916 through the effort of people like Charlie Russell and Theodore Gibson, Young Boy and the rest of his Canadian Cree people were homeless wanderers in Montana. The Cree and the Chippewa they mixed with were regarded by many Montanans as vagrants living off the refuse from slaughter-houses and what money they could beg or steal. Charlie deplored this callous attitude. "Lots of people seem to think that the Indians are not human beings at all and have no feelings," he once stated. "These kind of people would be the first to yell for help if their grub pile was running short and they didn't have enough clothes to keep out the cold, and yet because it is Rocky Boy and his bunch of Indians they are perfectly willing to let them die of hunger and cold without lifting a hand."

The Indians were willing to work, and took what odd jobs they could get cutting wood or helping out as ranch hands. The establishment of the reservation did not eliminate their need for outside income, and in 1923 Charlie was happy to provide Young Boy with a character reference, citing the greatly respected Theordore Gibson's recommendation and his own thirty-seven years' experience with a man he was proud to call his friend.

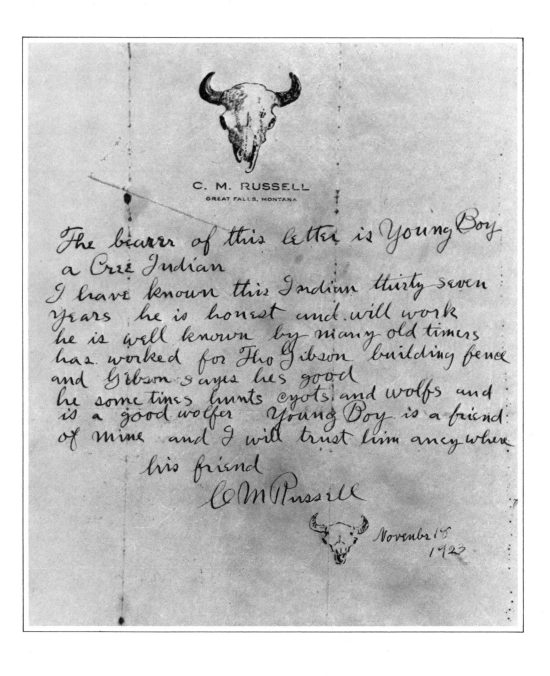

C. M. RUSSELL
GREAT FALLS, MONTANA

The bearer of this letter is Young Boy
a Cree Indian
I have known this Indian thirty seven
years he is honest and will work
he is well known by many old timers
has worked for Tho Gibson building fence
and Gibson sayes hes good
he some times hunts cyots and wolfs and
is a good wolfer. Young Boy is a friend
of mine and I will trust him aney where
 his friend
 C M Russell
 Novenbr 18
 1923

DEAR MISS JOSEPHINE, *March 27, 1924*

Albert Trigg's death in 1917 did not alter the Russells' intimate relationship with their next-door neighbors. Margaret and Josephine Trigg regularly stayed at Bull Head Lodge, and on occasion joined Charlie and Nancy for a few weeks in California. The passing of time simply strengthened the friendship. Josephine Trigg's 1924 birthday greeting to Charlie found him in an unusually reflective mood. The previous year had been a hard one. A bout with rheumatism had been a terrible strain, and Nancy too had been bedridden. An old friend who visited in January was "greatly distressed" to find Charlie "looking so aged and tired. I spent every night and most afternoons with him for a week, and at his request answered the calls on the phone from his many friends enquiring after his welfare, for he could get about only with difficulty, and Mrs. Russell was herself absent and ill in the hospital." But by late March there were some hopeful signs again. Russell's exhibition at the Biltmore Salon in Los Angeles was a going concern, and Nancy was elated. "We are meeting gobs of folks and things look O.K. so far," she reported home.

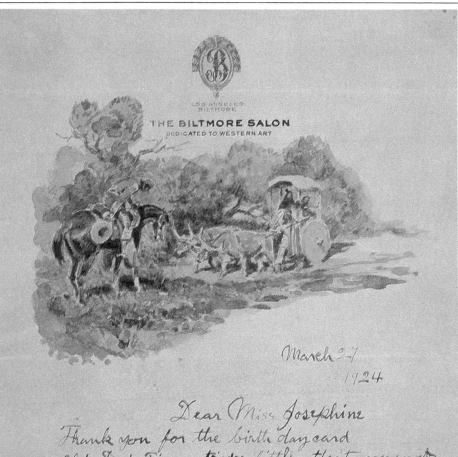

March 27
1924

Dear Miss Josephine

Thank you for the birth day card
Old Dad Time trades little that men want
he has traded me wrinkles for teeth
stiff legs for limber ones
but cards like yours tell me he has left me
my friends and for that great kindness
I forgive him,
Good friends make the roughest trail easy
Mame and I are much better
a few days more and I think I'l shed the stick
Jack seems to like school.
the above sketch is before Cal. was taken
by the Iowans
 with best wishes to you and
 your mother and Miss Furnald
 Your friend C M Russell

FRIEND FRANK, *April 24, 1924*

"I have shed the sticks." Few words could have given Charlie more pleasure to write. He was not yet fully recovered from the siege of sciatic rheumatism that struck in the fall of 1923 and confined him to bed for several months, but the worst was over and he was on the mend. Best of all, he was no longer on crutches. By their encouragement, he wrote Frank Linderman, "my Friends cleared the trail for me." Since the Russells and the Lindermans had lived side by side in Santa Barbara the year before, Charlie filled Frank in on a recent visit there with Ed Borein. He clearly relished the story of Borein's problems with a peripatetic mule, noting that he had told Borein if he would send a burro hide to Kalispell, Harry Stanford, the local taxidermist, "would build him a burrow that would stay in one place." The Lindermans, who had relocated in Kalispell temporarily, would be sure to pass this comment on to Stanford.

he starts standing on his hind legs triming
the clothe lines union suits and lingerie
was good pickings but he balked on corsits
the ladys dident Kick much
caus they dont use many
clothe these days but the hes of the
naborhood put up a rore that
could be herd plane at San Pedro
then a kid telephones wantin to
know if Ed wants to sell long ears
and Eward sells for reasonable prices
well Frank as Im out of paper talk Il

Friend Frank I am answering your many
letters because I did not answer them all dont
mean that I did not appreacate them but the
pen to me is the same as a pick its work
and Im one of the men that sweats when I
write the medicon virs you sent
worked I have shed the sticks I am
still a littel sprung in the nees an I dont
have to blow a horn to warn the trafick a
slice of hart from a friend some times is better an
alway easier to take than the branes of a docter
your medicon came from the hart and wase
scunataps the Doctors showed me the way to
go but my Friends cleared the trail for me
we went to Santa Barbra a fiew days ago and saw
the bunch they all sent regards to you and
yours Borien has a fine doby house and to
make it look real Mexico he bought a burrow but
they had to get rid of him caus he wouldent
stay in one place only long enough to grase

off a flower bed and when he got the hole
nabor hood looking like an over stocked sheep
range he starts standing on his hind legs
triming the clothe lines union suits and
lingerie was good pickings but he balked on
corsits the ladys dident kick much caus they
dont use many cloths these days but the hes of the
naborhood put up a rore that could be herd
plane at San Pedro then a kid telephones
wantin to know if Ed wants to sell long ears and
Eward sells for reasonable prices well
Frank as Im out of paper talk Il close
with best whishes to you and yours
the same gose to all friends
your friend C M Russell
P.S. I told Ed if hed send a burrow hide to
Kalispell that Harry Stanford would build him a
burrow that would stay in one place regards
to Harry
Adress 1323 3rd av Los Angles Cal

FRIEND BILL, *May 3, 1924*

William W. Cheely was vice-president of the Montana Newspaper Association. He and his partner Percy Raban wrote a series of syndicated stories that appeared in Sunday newspapers from coast to coast in the early 1920s under the heading "Back Trailing on the Old Frontier." Russell provided the illustrations. In this letter to Cheely he brings in a reference to Montana history by equating the plight of Little Bear's Canadian Cree refugees with that of California's native sons who had been displaced by the tourist—a familiar theme in Charlie's catalog of complaints about California.

A few years before, he had written to Guy Weadick about their friend Jim Parker: "Jim is with the movies when the hero of the play is supposed to spur his horse off a cliff in to the sea, 60 feet be lo to save his sweet heart from the sharks . . . they say photoes dont lye but I know moovin ones do where the hero quits Jim steps a cross a horse thats locoed and as big a dam fool as the man that rides him and goes off in to the sea . . . the people looking at the screen wonder at the nerve of the hero, they dont know when Jim takes the brainless leap Mr Hero is sitting back of the camera man in a coushened catalack smoking a camal."

In his letter to Cheely, Charlie paid Harry Carey the highest kind of compliment when he remarked that "Carey dont use a double hes nervy as the rest."

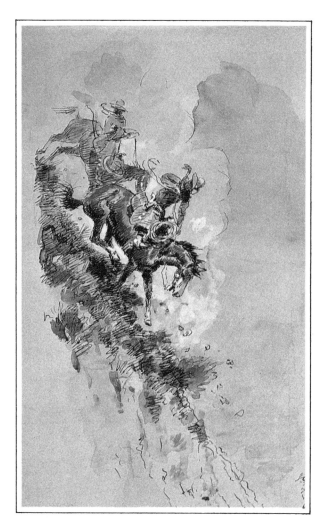

Friend Bill

I am still in the land of what ust to be the nativ
sons but since Iowa came a native son has as
much to say in Cal as Littel Bears folks do in
Montana the fiew natives Iv met were good
fellowes but thair fiew and scattered them and
long haird wimen are all most extinct we
was out with Harry Carry and spent a fiew
days at his ranch its about forty miles
from Los had a good time watching him and
his bunch making moovies since I saw
this bunch worke I take back aney thing I ever
said with my hat in my hand about
moove cow boys thair good riders and
hard to scare I usto wonder why movie
riders always rode up or down hill but Im wise
now aney peace of land thats level and big
enough to hold your hat in Califonia is a farm and
theirs a nester howing it so the moovies have
use that thats standing on edge Carey dont
use a double hes nervy as the rest the
director who has the onley soft thing on the job
findes a place where he can balence and
then picks out a hill that I wouldent go
near enough to throw a rock over then Mr
Director tells this bunch of no frades
through his megifone to come off maby
its coming off but it looks to me more like they fell
off of corse they hit often enough to ease the
fall. with the boose thair making these days I can
partly understand the punchers being fearless
but non of the horses I ever knew drank whisky
maby its loco that makes grass eaters foolish
Cary told me that non of his horses used boose
but not to bet that way on his riders I myself
dont think that CoCoCola ore mapel nut
Sundays would make moove cow boys as neather
of these drinks are brave builders Well Bill tell
the bunch Im on my my legs again give my
regards to every body best wishes to you and
yours your friend
C M Russell

195

FRIEND KNIGHT, *June 14, 1924*

Charlie Russell probably met Ray Knight at the 1912 Calgary Stampede or at the Winnipeg Stampede the next year, when he served as one of the competition judges. A rancher in southern Alberta, where the town of Raymond bears his name, Knight enjoyed the unusual distinction of being portrayed by Russell in a 1918 oil. While Charlie often put himself and old cronies in his paintings, he was quick to say that he was not a portrait artist and none of his other major works depicts a modern-day cowboy of his acquaintance. Knight maintained his association with the Calgary Stampede after it became an annual affair, and in 1924 extended the usual invitation to Charlie to take in the show. Had Charlie been able to attend, he would have seen Knight in top form, since the veteran from Raymond, as the press dubbed him, won the calf-roping championship that year.

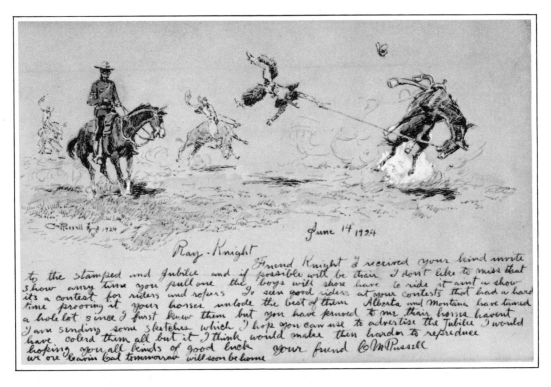

Friend Knight I received your kind invite to the
stamped and Jubilee and if possible will be thair
I dont like to miss that show aney time you pull
one the boys will shore have to ride it aint a
show its a contest for riders and ropers Iv
seen good riders at your contests that had
a hard time prooving it your horses unlode
the best of them Alberta and Montana
have tamed a hole lot since I first knew
them but you have pruved to me thair horses
havent I am sending some sketches
which I hop you can use to advertise the
Jubilee I would have colerd them all but it I
think would make them harder to repreduce
hoping you all kinds of good luck your friend
C M Russell
we are leavin Cal tommorrow will soon be
home

Ray Knight Roping a Steer, *oil, 1918*

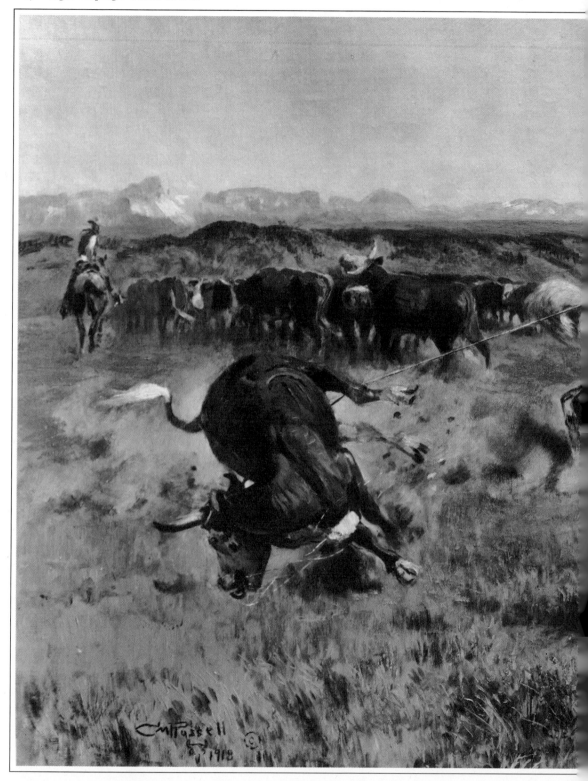

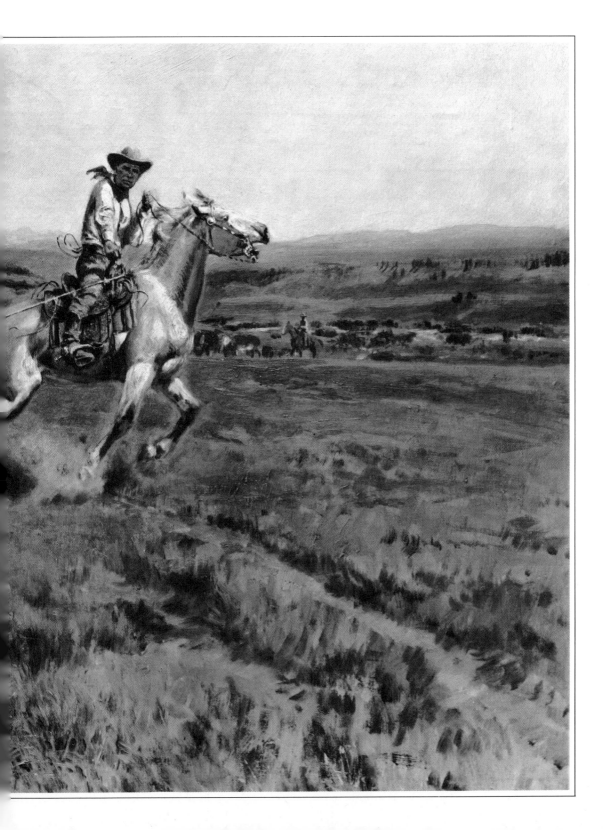

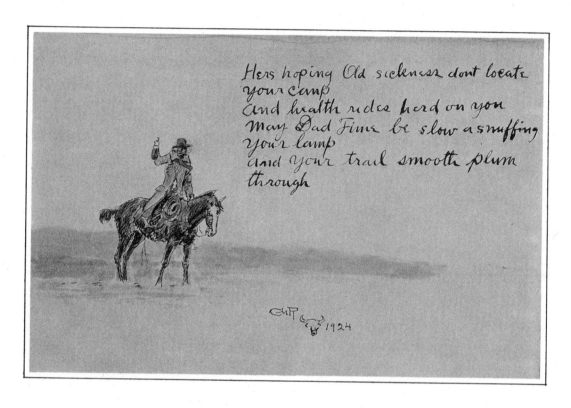

Hers hoping Old sickness dont locate
your camp
and health rides herd on you
May Dad Time be slow a snuffing
your lamp
and your trail smooth plum
through

FRIEND ED, *November 9, 1924*

Nothing dramatized Charlie's deteriorating health more poignantly than his inability to join his friends on their annual fall outing. His sciatic rheumatism kept him grounded two years in a row. Obviously he was missed, since Ed Neitzling did not enjoy the hunt in 1924.

Charlie always knew that health was the key to happiness. His Christmas and New Year's cards had often expressed that sentiment. As his own health declined, and pain and the strange new burden of his years took their toll, Charlie wished others good health all the more fervently. This 1924 greeting tells its own story.

C. M. RUSSELL
GREAT FALLS, MONTANA

November 9 1924

Ed. Neitzling

Friend Ed again I thank
you for that fine hind quarter of deer
it is shure fine thair is no meat as good
as the wild for me
I am sorry you dident have a good time on
your hunt
this fall makes two years Iv missed
I am as you know a harmless hunter but
I shure like to git out with a good bunch
the old rumitism I dont know whether that
the way to spell it or not but it is still with
me but by next fall I hope to git out
with the same good bunch we shure had
a good time with best regards to you and
all friends
thanking you
your friend
C M Russell

DEAR MAME, *December 1, 1924*

Even as his health betrayed him and the clock ticked away his hours, Russell worked on, content with his life and what he had made of it. His letter to Nancy, written on her stationery during one of her infrequent absences, is oddly haunting. The domestic details, the sense of comfortable routine, and the almost palpable hush falling over the Russell household at the end of a December day—all seem to capture the essence of the Cowboy Artist in his twilight years. Joe de Yong, who studied with Russell in his studio beginning in 1916 and knew him as well as anyone in the last decade of his life, observed that "all he wanted out of life was a chance to work, his horse, his home, friends to tell stories to—and the price of a picture show." The Banty mentioned in Charlie's letter was Joe's mother, Mary de Yong, who managed the Russell household and baby-sat their adopted son Jack when Charlie and Nancy went east later that December.

NCR

Dec 1
1924

Dear Mame you have
been gone one night and a day
and the hous is al redy lonsum
I hope you did not get car sick
Banty is feeling bitter but still on
Short feed all others fine it is
now half past five Jack s out
side playing I finished my picture
will start the other to morrow
still beautiful whether went to a
show with Theo Gibson saw Richard
Barthelness in Class mates it was good
With love and X X Y X Y,
Your loving husband
C M Russell

FRIEND GUY, *April 7, 1925*

Women were among the featured attractions in Wild West shows and early rodeo. There was a succession of Annie Oakleys, though none of the others enjoyed her fame. Guy Weadick, whose wife was a star performer, had good reason to recognize the appeal of the ladies. The advertising for the Victory Stampede in 1919 included this tantalizing copy:

> ### Cowgirls
> THE SAUCIEST, MERRIEST, LOVELIEST
> ASSEMBLAGE OF FEMINITY [*sic*] THAT EVER GALLOPED
> INTO CALGARY; GIRLS WHOSE YOUTH AND
> BEAUTY SEEM TO CRY OUT
> AGAINST THEIR HAZARDOUS, LIFE-RISKING EXPLOITS.

This was not all come-on. Women bronc riders did take their lumps along with the men, and they earned Charlie's respect as gritty performers.

Though he pretended otherwise, Russell was quite competent at rendering the female form, even if he was not about to offer such celebrated "Girl painters" as Harrison Fisher and Charles Dana Gibson any serious competition. The cowgirl in the pair of sketches he sent Weadick—*Bucking Horse and Cowboy* (watercolor, n.d. [1925]) and *Bucking Horse and Cowgirl* (watercolor, n.d. [1925])—attests to his versatility and ease with an unaccustomed subject.

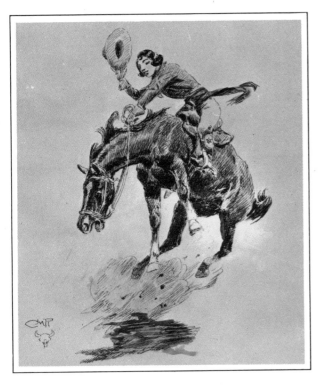

Friend Guy

I am sending you two sketches that you might use
on your pape they could be reduced and
used on your programes the Girl bronk rider is
new for me and if Harison Fisher Gibson or
aney of those Girl painters would see it they
might get sore and say I was crowding
thair range but I saw a Gibson cow boy and Il
admit my Cow Girl dont look near as
ladylike as his cow puncher did but my Girles
are bow legged. and riding snakey horses
dont help refine nobody and correll dust
dont beautiefy bow legs on a lady dont look
good but they fit a horse and thats the kind
Calgary wants Guy I just recived your kind
invitation and will shure be thair With best
whishes to you and yours your friend
C M Russell

FRIEND TED, *January 27, 1926*

As readers of his letters know, Charlie was a master storyteller. His contemporaries praised him as a polished raconteur who combined a low-key delivery with an uncanny ability to individualize both people and animals. He just "hunkered on his heels and let wisdom seep out of the squeezed corner of his lips like sugar dripping from a sugar tree," Irvin S. Cobb recalled in *Exit Laughing.* But it was still a big step for Charlie from storytelling to story-writing, and when his first collection of tales, *Rawhide Rawlins Stories,* was published in 1921, he had every reason to be proud. Characteristically, he took no special credit, attributing his gift for vivid narrative to circumstances: "Where there's nothing to read, men must talk, so when they were gathered at ranches or stage stations, they amused themselves with tales of their own or others' adventures. Many became good storytellers. I have tried to write some of these yarns as nearly as possible as they were told to me."

To a woman who inquired in 1923 which of the Rawhide Rawlins stories he thought best, Charlie replied, "I asked a man once which was the best hotel in Medicine Hat he said if I'd asked him which was the worst he might tell me but hed be damed if there was any best. I think its the same with Rawhide Storys."

More Rawhides, a second collection of Russell's stories, appeared in 1925. Charlie inscribed a copy to Teddy Blue Abbott, who figured in some of the tales, with the advice that he could trade it off for a *Police Gazette* "ore some other good reading" if he already had the book. Baldy Buck was Belknap Buck, a mixed-blood Gros Ventre and a cowboy crony of Charlie's and Teddy Blue's from the 1890s.

Jan 27 1926

Ted Abbot

Fernend. Ted if your got one
of these trade it off for a ~~Police~~ Gagett
ore some other good reading

I dident know you wanted one till I got
your letter I'm sorrey you didnt
git a gushe after puncliing all them
holes in your ranch

badger holes are bad enough in a
Cow range and oil holes must be
worse maney a man got a harder
fall in an oil hole them that a
badger made might brake a leg
but ~~them~~ that men mad looking for oil
brake men

but Ted go back to the Cows you savy them
they wont double cross you

I saw Pulay Buck once since we saw him
has still with F

 best wishes to you and your
and all friends
 your friend
 C M Russell

DEAR MISS JOSEPHINE, *March 24, 1926*

Josephine Trigg taught drawing in the public schools and was a high-school teacher before she became librarian in the newly opened children's room in the Great Falls Public Library in 1911. The stories of adventure in faraway places and olden times that entranced her young audiences also appealed to Charlie, and Josephine occasionally read to him while he worked. The paintings he gave the Trigg family each Christmas ranged around the world in subject matter, from Egypt and the Holy Land to England in the Middle Ages and New England in colonial times. Thus in his letter thanking Josephine for her birthday greeting—with its shamrock for good luck—Charlie remarked on how Hollywood brought fantasy alive. (The comments on Moses referred to the filming of Cecil B. de Mille's *Ten Commandments* in 1923.)

The "Miss Furnald" mentioned in Charlie's letter to Josephine Trigg was Louise Fernald, head librarian in Great Falls from 1912 to 1945, when she and Miss Trigg both retired.

The undated pencil sketch of Miss Josephine (above) may well have been done while she read aloud to Charlie one day.

March 24 1926

Dear Miss Josephine I want to thank you for
the nice birth day card you sent and your
Shamrock has brought luck as I feel much better
to day not that Iv been sick but I havent felt
real good that card was shure a Paddys
greeting maby Im not Irish but my fondness for
that Race makes me belive Im a breed. You
said the verse was not all yours but I know
the feeling was and thats the best part of
it. Miss Josephine California is not the country
that Bret Hart knew but the moovie people
still make romance the English woods
you see on the screen at the Liberty or aney
other show house are realy live oaks of
Cal so you see in 1926 when everything

is forgoten but right now you are apt to meet
armored men of Ritchard the Lion Harteds
time I fiew years ago you might of seen Moses
and his bunch heading for the sea some where
betwine Long Beach and Santa Barbra maby
they had harps but if they played it was jass music
the same as youl here at the Odan ore Meadow
Lark Club. Moses is here yet I saw him the
other day I dont know what hes doing now but
its a safe bet he cant write the ten commadments.
Jack is going to school and we are all well
With best whishes to yourself and Mother and
Miss Furnald from us all Your friend
C M Russell

FRIEND BEAL, *May 31, 1926*

Like Joe de Yong, Charlie Russell's best-known protégé, Charles A. Beil worked as a cowboy and a Glacier Park guide before taking up art full-time. A Colorado native, he moved to Great Falls in 1922 to be near his idol, the by-then legendary Cowboy Artist. Through mutual acquaintances Beil met Russell at The Como Company and overcame his nervousness long enough to show him a model he had made of a burro. Russell was favorably impressed. He introduced Beil around, promoted his work, and praised him as "the greatest modeler of western scenes he had ever known." Though Charlie apparently never bothered to learn Beil's first name, their relationship was close enough that Beil was chosen to lead the saddled, riderless horse in Russell's funeral procession.

In 1930 Beil moved to Banff, where he established a solid reputation as a sculptor. Each year he fashioned the statues awarded as trophies to the top performers at the Calgary Stampede—an assignment that would have particularly pleased Russell.

This letter indicates Charlie's continuing interest in cowboy fashions and a cause that won his passionate support in the last year of his life, the preservation of Montana's wild horses, which were facing extermination as a health hazard.

Friend Beal

I got your letter some time ago but lost it and dont
know your frunt name so am sending this in care
of Joe De Young the photoes of your modle
looked good I got a letter from Joe he says
your doing lots of work About three weekes
ago I went to see a Cousin of mine who
is a cow man and lives at Holister Cal he
invited me to a rodeo where I saw the Buckarues
brand out I was thair at the Qun Sava
Ranch two days and they branded about one
thousand calfs Saw some good roping
and they rode good horses these Buckarues
are more like the cow punchers of long
ago than aney Iv seen they still use
senter fire saddels and a raw hide ropers most
of them use raw hide ranes and thair all dally
men maby they cant work as fast as tie men
but they shure do thair work pritty the Iron of
this ranch is QS on left hip ear mark
[sketch] Cal is the only place I ever saw real
cow Girls there were a fiew on this rodao
that could handle a rope but they dident look
like they knew what a lip stick was thair eye
brows were the ones that God gave them and its a
safe bet that they knew more about a brand
book than the Ladys home Journal I sorry to
hear thair killing range horses Iv got two
on the flat head resuration I suppose when I
want them I get them with a can opener but
I read in the paper where horses were

braking down fenses I have known horses that
got cut pritty bad but non that broke a fence
down but when ever aney thing quit bring the
money the Scientific Man aint slow in
proving that that beast ore bird should be wiped
out a fiew years ago one of these wise men
said that the Mountain goat had ticks that
gave men the spotted feaver and wanted the goats
killed off the fiew goats Iv seen lived in a
country that had nothing but helthe and it took a
man not a scientist to get one with a long
range rifel to get a goat I dont beleave
animals ever gave aney germs to man but it
might have went the other way a long time
ago when I was working on the range
a fiew horses in my string got lousy to
be honist I think they got them from
me I was short on bedding and was using my
saddle blanket if mountain goats give
people ticks why dont sheep hearders get the
scab Man cant win much fighting nature
when the cyote was plenty thair was feew gophers
or rabbits now the hole west swarms with
them but Beal whats the use kicken I got
non coming when I came west I got the
cream let the come latlys have the skim milk
we expect to start home pritty soon and I hope to
see you soon with regards to every body
 your friend
C M Russell

DEAR MISS ISABEL, *July 30, 1926*

Charlie's other health problems were complicated by a steadily worsening goiter condition. It was operable, but Charlie, openly admitting that he was afraid to undergo surgery, put the operation off until it could no longer be avoided. By the time the goiter was removed at the Mayo Brothers' Clinic in Rochester, Minnesota, Charlie's already weakened heart had been further damaged. But as the letters wishing him a speedy recovery poured in, Charlie looked forward joyfully to his return home. "Since I came to Rochester, I love aneything in Montana," he wrote one friend. "If I had a ratler snake here and I knew he was from Arrowcreek I couldent keep my hands off him." Among those who sent Charlie a get-well letter was Isabel Brown, the young daughter of H. P. Brown of the Great Falls Meat Company and a neighbor of the Russells. Touched, Charlie replied with this thank you. The little drawing of a mountain goat is significant. The goat symbolized the wild country in Glacier Park that Charlie had always loved. And it told a story that he had explained when he sent a similar sketch to a friend years before: "Old John like the animal above is in a dam dangiros place but the goat dont think so and if I can make my friend feel like the goat I belive hel come across the bad pas." For Charlie, as events proved, there would be no trail down to safe ground.

July 30
1926

Miss Isabel Brown

Dear Miss Isabel

I received your kind letter and was
glad to here from you
When I get aney thing in the mail
thats not a bill it a safe bet its
from a friend
I got moore letters while I was in
Rochester than ever before in my hole
life ~~before~~ but not one from an
under taker
Miss Isabel My friends gave me neive
to go up aganst the knife
I glad I went to Rochester but the best
end of the trip was coming west

as I said before I got letters
from maney friends
but yours was from my youngest
friend
to write a letter take time and young
folks use a lot of that
and whene they use aney of it on
me I appreciate it
wer all up at Lake MacDonald having
a good time
I'm weak yet but am getting back
slow
With best wishes to you
Your Father and Mother
your friend
CM Russell

DEAR MISS JOSEPHINE, *August 28, 1926*

Two months before he died, Charlie could still put his own worries aside while he congratulated a dear friend on the occasion of her fifty-fourth birthday. Long after Charlie and Nancy had both passed away, Josephine treasured every memento of the artist's skill given members of her family, and in her will she presented this uniquely personal collection of Russell's work to the people of Great Falls. It has been housed in the C. M. Russell Museum on the site once occupied by the Trigg home beside Charlie's log cabin studio, an enduring tribute to the Trigg-Russell friendship.

August 29
1926

Dear Miss Josephine

This card will remind you that some years ago a messenger flew in to Michigan from the land of Birth Days and left a bundle of happiness.

Dad Time with sorrow have torn the wrappings some but the happiness inside was so strong that it still holds together.

May it remain so to the end.

Your friend
C M Russell

FRIEND COLE, *September 26, 1926*

Dr. Philip G. Cole was born in Montana and educated in the East. After graduating from Columbia Medical School, he practiced medicine in Helena until World War I called him away. He never returned either to medicine or Montana, but joined his father in a manufacturing firm in Brooklyn and amassed a fortune. He did not forget Montana, however, and he used some of his wealth to surround himself in his baronial mansion in Tarrytown, New York, with reminders of the West he had left behind. He bought his first painting—a Charles Russell oil—in 1919. Through Russell he became acquainted with the work

of another Great Falls artist, Olaf C. Seltzer, who had known Russell since 1897 and aspired to follow in his footsteps. In 1926 Seltzer went to New York City where he found opportunities to make a living from his art. Dr. Cole was his major patron, and almost half of the 560 paintings in the Cole collection were pieces he commissioned Seltzer to do on Montana themes. Today they repose with Cole's splendid selection of the works of Russell, Frederic Remington, and other western painters in the Thomas Gilcrease Institute of American History and Art at Tulsa, Oklahoma.

Charlie's letter to Dr. Cole is the last illustrated letter he is known to have written. Its lovely vignette, with its autumnal coloring and sense of tranquillity, seems particularly appropriate. A month later Charlie was dead, and shortly after Will James, the cowboy artist and author whose books Russell praises, penned a sentimental tribute in a letter to Dr. Cole: "I'm building that home in the heart of the cow country. . . . I wanted awful bad to fix up my corrals, scatter out my log and dobie buildings, and then have good old Charlie Russell come rest his feelings at the sight. . . . With that old cowboy gone I feel as if the lines of the cow country have give away—I know it ain't true and that the cow country is up to stay a long time yet, but anyway I want to play safe and get my little territory where I'll be able to look around as it is now and without seeing a fence, I want to feel sure that I'll always have space to really breathe."

September 26
1926

Dr Philip Coll
 Friend Coll
I just received your gift the bookes by
Will James
which I like verrey much
when it comes to horses nobody can beat
James
thair is no other horse like our range
horse and James savys every moove they make
we have just returned from our mountian
camp the big hills look verry beautful in
thair fall clothing of maney colers
the above sketch is of a small band of
Elk we saw a few days before we left
which I hope will remind you of the
Country you were born and raissed in
the camp you live in now can bost
of man made things
but your old home is still the real
out doors

and when it comes to makeing the beautifull
Ma nature has man beat all ways from
the ace
and that Old lady still owns a lot of
Montana
to show what I mean man made this
animal but the old lady Im
takeing about made this one

 I have made a living painting
 pictures of the horned ox and
the life about him it took regular men
to handle real cows
I would starve to death painting the hornless
deformity
God made cows with horns to defend herself
and when a wolf got meat it wasent easy
often he was so full of horn holes he wasent
hungry
a weasel could kill the man one with out
getting a seratch
but I forgot Iv got no kick coming Iv
been turned my self
but the medicine men at Rochester
ovely took from me things I dident need
and was glad to get rid of
I look and feel better but Im still verry
weak
if you see Olaf Seltzer give him my
regards
I suppose by this time hes a real New yorker
we have been having lots of snow but to day
it has chinord and I think the storm is over
we all send our best regards to you and
yours your friend
 C M Russell

Russell's funeral procession, *October 26, 1926.*

After removing Charlie's goiter, the doctors informed him that he had perhaps six months to live. He did his best to keep the news from Nancy who, already advised of his heart condition, struggled to keep the news from him. "I have throwed my last leg over a saddle," Charlie told a Great Falls friend in September. "The old pump's about to quit." The end came peacefully on October 24. Bob and Effie Thoroughman were house guests and they passed a pleasant evening with the Russells talking over old times. Great Falls had been enjoying an unusually fine Indian summer and Charlie was feeling chipper. But, he told Bob over his nightly glass of hot milk, he could not gain strength. The two couples retired to bed about 10:30. The Thoroughmans could hear Charlie struggling for breath in the next room. Shortly before midnight Nancy came in and announced that he was dead. "We stayed up with her the rest of the night," Effie remembered. The funeral was held on October 26. City offices were closed and schoolchildren let out to honor Russell's memory. An honor guard of Elks accompanied his body from his home to the church, where it lay in state until the funeral.

Not long before he died, Charlie finished the sketch for the Russells' 1926 Christmas card, had it printed, and hand-colored a few copies intended for personal friends. As always, he wished others smooth trails ahead and good health and happiness through the rest of their days.

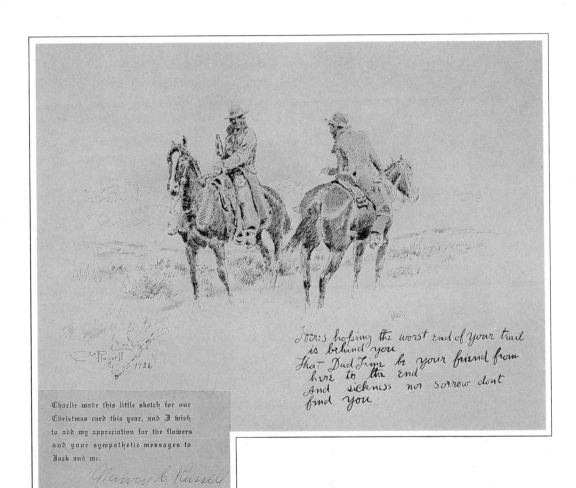

Here's hoping the worst end of your trail
is behind you
That Dad Time be your friend from
here to the End
And sickness nor sorrow dont
find you

Charlie made this little sketch for our
Christmas card this year, and I wish
to add my appreciation for the flowers
and your sympathetic messages to
Jack and me.

Nancy C Russell

ACKNOWLEDGMENTS

Without the generosity of many individuals and institutions *Paper Talk* would not have been possible. I would like to personally thank the following for their kind assistance: Dorothy Dickinson Ball, Great Falls; Edward E. Cooney, Minneapolis; Mrs. Jack DeCarlo, Mount Prospect, IL; Chris Dickinson, Jr., Great Falls; Kenneth V. Dunlap, Great Falls; Terry Eastwood, Victoria, BC; Harrison Eiteljorg, Indianapolis; Mr. & Mrs. Duane W. Gagle, Bartlesville, OK; Allan Hooper, Butte; Alex Johnston, Lethbridge, Alberta; Joseph T. O'Connor, Vancouver, BC; John A. Popovich, Corning, NY; C. Owen Smithers, Jr., Butte; C. M. Russell Original Log Cabin Studio, Great Falls; Glenbow-Alberta Institute Library and Archives, Calgary; Indianapolis Museum of Art; Montana Historical Society, Helena; Provincial Archives of Alberta, Edmonton; Sir Alexander Galt Museum, Lethbridge; and the C. M. Russell Museum, Great Falls, where Ray Steele and Joseph S. Wolff extended themselves in many ways to facilitate my research.

I cannot fail to mention my parents, who introduced me to Russell's work in 1949, and my wife Donna, whose honeymoon included a day in Great Falls at the Museum and Studio. Finally, special thanks to Kay Krochman at Amon Carter, my collaborator in bringing this new *Paper Talk* to completion.

<div align="right">Brian W. Dippie</div>

SELECTED BIBLIOGRAPHY

Abbott, E. C., and Helena Huntington Smith. *We Pointed Them North: Recollections of a Cowpuncher.* Norman: University of Oklahoma Press, 1955 [first pub. 1939].

Adams, Ramon F., and Homer E. Britzman. *Charles M. Russell, The Cowboy Artist: A Biography.* Pasadena: Trail's End, 1948.

————. *The Old-time Cowhand.* New York: Macmillan, 1961.

Bollinger, James W. *Old Montana and Her Cowboy Artist.* Shenandoah, Iowa: World Publishing, 1963.

Boyer, Mary Joan. *The Old Gravois Coal Diggings.* Festus, Mo.: The Tri-City Independent, n.d. [1954].

[Charles M. Russell Museum]. *C. M. Russell, A Legendary Man, 1864–1926.* N.p. [Great Falls], n.d. [1977].

Cobb, Irvin S. *Exit Laughing.* Garden City, N.Y.: Garden City Publishing, 1942.

Coburn, Walt. *Pioneer Cattleman in Montana: The Story of the Circle C Ranch.* Norman: University of Oklahoma Press, 1968.

————. *Western Word Wrangler: An Autobiography.* Flagstaff, Ariz.: Northland Press, 1973.

Crossen, Forest. *Western Yesterdays, Vol. IX: Charlie Russell—Friend.* Fort Collins, Colo.: Robinson Press, 1973.

Davidson, Harold G. *Edward Borein, Cowboy Artist: The Life and Works of John Edward Borein, 1872–1945.* Garden City, N.Y.: Doubleday, 1974.

Dykes, Jeff C., ed. *The West of the Texas Kid, 1881–1910: Recollections of Thomas Edgar Crawford.* Norman: University of Oklahoma Press, 1962.

Hart, William S. *My Life East and West.* Boston: Houghton Mifflin, 1929.

Kennon, Bob, as told to Ramon F. Adams. *From the Pecos to the Powder: A Cowboy's Autobiography.* Norman: University of Oklahoma Press, 1965.

Linderman, Frank Bird. *Recollections of Charley Russell,* ed. by H. G. Merriam. Norman: University of Oklahoma Press, 1963.

McCracken, Harold. *The Charles M. Russell Book: The Life and Work of the Cowboy Artist.* Garden City, N.Y.: Doubleday, 1957.

Noyes, Al. J. *In the Land of Chinook; or, The Story of Blaine County.* Helena, Mont.: State Publishing, 1917.

Price, Con. *Memories of Old Montana.* Hollywood, Calif.: The Highland Press, 1945.

————. *Trails I Rode.* Pasadena, Calif.: Trail's End, 1947.

Renner, Frederic G. *Charles M. Russell: Paintings, Drawings, and Sculpture in the Amon G. Carter Collection.* Austin: University of Texas Press, 1966.

————. *Paper Talk: Illustrated Letters of Charles M. Russell.* Fort Worth, Tex.: Amon Carter Museum of Western Art, 1962.

Rinehart, Mary Roberts. *My Story: A New Edition and Seventeen New Years.* New York: Rinehart, 1948.

Russell, Austin. *C. M. R.: Charles M. Russell, Cowboy Artist.* New York: Twayne, 1956.

Russell, Charles M. *Good Medicine: The Illustrated Letters of Charles M. Russell.* Garden City, N.Y.: Doubleday, Doran, 1930.

————. *Greetings from Great Falls, Montana.* Great Falls: B.P.O.E. No. 214, 1956.

————. *Trails Plowed Under.* Garden City, N.Y.: Doubleday, Page, 1927.

[Russell Memorial Committee], *The Log Cabin Studio of Charles M. Russell, Montana's Cowboy Artist.* Great Falls: The Russell Memorial Committee, n.d. [1930].

Sotheby Parke Bernet Inc. *Paintings, Watercolors, Bronzes, Illustrated Letters, Books and Ephemera by Charles M. Russell: The Collection of Fred A. Rosenstock, Denver.* New York: Sotheby Parke Bernet, 1972.

Stout, Tom. *Montana: Its Story and Biography.* Chicago: The American Historical Society, 1921.

Stuart, Granville. *Forty Years on the Frontier,* ed. by Paul C. Phillips. Glendale, Calif.: Arthur H. Clarke, 1925.

Vaughn, Robert. *Then and Now; or, Thirty-six Years in the Rockies.* Minneapolis: Tribune Printing, 1900.

Yost, Karl, and Frederic G. Renner, comps. *A Bibliography of the Published Works of Charles M. Russell.* Lincoln: University of Nebraska Press, 1971.